Contents

Preface

This book is a free montage of conversations we had with artists, activists and political thinkers between 2013 and 2014 in the aftermath of the protests and occupations against austerity that took place during 2011. That moment and in particular the coalescing and dissipation of Occupy, represented a catalyst for working together on this project. Being involved in many of the initiatives at that time, in particular the three workshops organised by the Precarious Workers Brigade at Occupy London, we both felt that we had seen and heard something powerful in the way that activist practices had taken up and, in some cases, have continued to work with and through listening. We pictured this as an act of collective listening capable of bringing people together and as even as a force that needed to be explored further. This moment also coincided with the two of us reappraising our own relationships with dominant modes of production and distribution of art, and the urge to question the role of certain institutional frameworks in promoting both art and "creative" activism.

We started the project by talking to our friends, co-conspirators and colleagues especially artists and activists we have worked with before and for whom collaboration is an important part of their practice. Most of the conversations contained in the book feature ourselves in dialogue with artists Ayreen Anastas and Rene Gabri, Janna Graham and Robert Sember both members of the collective Ultra-red, and the Precarious Workers Brigade collective whose members wished to remain anonymous. There is no prescriptive rationale behind this choice, however their work does provide something of a spectrum of collaborative practices between what might be deemed activist and artistic modes of working. There is a grey area here, by nature slippery, and they all inhabit and navigate this differently. We are not trying, to chart a movement or a "scene", or to

frame a shift in art historical terms but rather to explore something we felt was important.

As well as looking at the present we were also interested in what historical traces we might find. The listening practices we investigate have not come out of the blue. There is a history here that even if forgotten or unknown can reappear. As soon as you begin to trace a historical thread, a moment is no longer isolated. It has roots, and therefore also new, possible future trajectories. In particular we wanted to trace some kind of legacy back to feminist practices of the 1960s and 70s. As a dialogic practice which valued listening as much as speaking, we realized that feminist consciousness-raising (C-R) groups were key to understanding the relationship between micro-politics and listening. We therefore wanted to revisit them not purely as a source of inspiration or theoretical reference but as a lived knowledge. Rather than any attempt at providing a wider and exhaustive analysis of C-R, we spoke with two women who were involved in C-R groups in the 70s: the anthropologist Pat Caplan and the artist Anna Sherbany. The issue of articulating and/or reassessing feminist theory through the experience and history of C-R is a complex and much debated one in itself. Again, there is not a prescriptive rationale behind this choice except the need to hear first-hand experience and to add Pat and Anna's voices to our dialogue.

Although this is a book coming most of all from practice, we also draw on theory to support and develop our arguments. Voice politics proved to be key for understanding listening as a political act and as an integral part of political action. The theorists we spoke to, media sociologist Nick Couldry and philosopher Adriana Cavarero, have written extensively on voice as a social and relational process, drawing both from feminist philosophy and political science.

The Force of Listening is an experimental book. The

conversations we had with all the interlocutors were free flowing rather than being fully structured interviews. Each speaker was allowed to veer off and meander in different directions. What surprised us when listening back to the recordings, was that definite topics emerged and developed through one conversation to another. Instead of collecting and presenting this material as separate moments in time, we opted for a long, constructed conversation in eight chapters or acts, each one resulting from themes, words and stories that echo and resonate with each other. The book owes its montage and dialogic form to Carla Lonzi's *Autoritratto* (1969) a work that deeply inspired us not only in its form but also as a symbolic threshold between art and activism: *Autoritratto* was Lonzi's last text written as an art critic before going on to write as a feminist. Like *Autoritratto*, which was an imaginary gathering between fourteen artists, our interlocutors only meet on the page, and in that sense there is a contradiction. In a real time conversation people have time to listen to each other, to take in what someone has said and to reply, agree or disagree. With this construction we hope that other kinds of listening can happen. While all writing is to some extent collage, in making the construction more explicit, we hope to allow for gaps and therefore possibilities to emerge as much as to build towards an argument. Above all we hope to start a conversation that can be continued.

In the writing of ourselves in these conversations, the "Lucia" and "Claudia" that are featured in the following pages, are also partially created constructs. It can be said that we are all constructs to some extent, being historically situated, shifting versions of our selves. By making the disjuncture between speech and writing visible, this can perhaps become more apparent. Our own drift towards politically engaged thinking and acting particularly in response to the precarious living conditions of the current historical juncture, has also been instrumental in feeding

into the project. We embraced the shift towards activism as a possibility to reinvigorate our energy, hope and willingness of creating a space for thinking and acting together in the face of crisis.

We would like to thank Brandon LaBelle and Riccardo Benassi for inviting us to take part in the Doormat series. Their generosity of time make this long trajectory possible. A special thanks goes to Alexis Bhagat, Adriana Eysler, Richard Crow, and Melvyn Firth for their help in transcribing some of the interviews and proofreading. A big thanks to Marc Herbst for reading the first draft and asking difficult questions! Thanks also to the Sound Gender Feminism Activism SGFA 2014 conference for hosting a first reading of the book in progress, and to PLANK for inviting us to the conference Techniques of Art and Protest 2015, this was a productive moment of exchange and feedback at a moment when we thought the book might never come to an end. A big thank you to Luciano Stoffella for hosting us in his house over a hot summer in order to allow us to spread the terrain in front of us. A huge thanks goes to our interlocutors who have trusted us with the montage of their voices and ideas, and especially PWB for offering much political ground from which to start our collaboration, Janna Graham and Robert Sember for helping us to delineate the initial trajectory; Ayreen Anastas and Rene Gabri for their surprising ability to de-tour and keep things open; a heartfelt thanks to Anna Sherbany and Pat Caplan for sharing their narratives and memories with intimacy and warm hospitality; and to Adriana Cavarero and Nick Couldry for their sharp insights into political theory. Many other conversations (which do not feature in this book) have also been enormously helpful for the development of this book: we would like to mention here Professor Rachel Beckles Willson for organizing a series of Listening Workshops at Royal Holloway, University of London, which were truly amazing moments of inter-disciplinary

exchange and critical reflection; thanks are due to Caroline Bergvall for inviting us to her very moving performance *Drift* and discussing with us her voice practice; and to Iris Garrelfs for hosting us in her sound art magazine *Reflections on Process in Sound*; and last but not least a big thank you to all our friends at The Field in New Cross and at the Common House, in Bethnal Green, for keeping (us) going and making such inspiring collective work.

London, 25 March, 2016

Introduction: The Terrain

We would like to invite you to pay attention to listening. But not just any listening. In compiling this book we wanted to address the role of listening in the context of contemporary intersections between art and activism and in particular in relation to social relations and collective practices. Our own experiences as cultural producers and activists have led us to come to the conclusion that the importance of listening in shaping the social and the political in this intersection has been overlooked and needs to be addressed in more depth. The subject of listening in general, is a subject on which not as much has been written as we thought should be, if we compare it for example with the exhaustive literature available on visual culture. There have been some philosophical inquiries into listening – Jean-Luc Nancy for example, and there have also been an increasing number of sonic studies texts that have focused on listening as an art practice in itself. A wide range of literature on sound art and audio culture published in the past ten years has reflected for example on new modes of listening introduced by the advent of radio and the use of recorded technologies (Cox & Warner; Kahn; Weiss)[1], its connection with site specific art and architecture (LaBelle)[2], and with discursive and conceptual art (Kim-Cohen)[3]. Although there have been attempts at presenting different practices of listening beyond music and sound experimentation (Carlyle & Lane)[4], what seems lacking today is a wider and more inter-disciplinary perspective on listening, particularly in regards to the relationship between art and politics. This lack also corresponds on the other hand to the little attention given to listening in the field of political theory. While there is a significant literature on the role of speech and voice in the political arena, very little seems to have been written on listening except by post-colonial feminist theorists Gayatri Spivak and Sara Ahmed[5], feminist political theorist Susan Bickford[6] and the

reflections of radical pedagogist Paulo Freire[7].

Rather than writing an academic text on the subject, we have edited a montage of conversations in order to reflect our interest in listening primarily as a practice. This conversational mode allows questions to be raised and addressed in a more open ended and dialogic way. This also reflects our focus in listening as part of the two-way process of dialogue rather than as an end in itself. We are interested in exploring what listening can do rather than just what it is. How it might be considered an action, and what transformations might occur as a result of doing the listening or being listened to. On a psychological level, this also can be linked to therapeutic practices. In the book, we investigate the role of listening in group formation and collective processes, how listening can be a political tool and the possibility of wider social and political change. For many of our interlocutors Hannah Arendt's notion of action has been a key reference point, and we therefore give this particular relevance and space in the book. We also however recognise how difficult it can be to define political action within the contemporary landscape[8] and discuss how listening might function in these debates.

Feminism seems the best place to look in order to address some of these issues. Intersections between the personal and political become vital for understanding the role of listening in this context, and feminist models of epistemology have precisely valued listening in a conversation as much as the speaking. We wanted to see if we could trace some kind of legacy from consciousness-raising as a listening practice because it did and still has key insights to offer. We also reference feminist writers, theorists and artists. However, rather than looking at specific identity issues that feminism has addressed (that may or may not have been redressed in our current time), we discuss how an ethics and politics of listening derived from feminism might inform social and political relations (and/or ideas of poli-

tics as relations). We draw inspiration from Adriana Cavarero's *politics of voices* in which the bond between Logos and politics is reconfigured[9] (in Chapter 3: *Towards a Politics of Voices*) and look back to notions of empathic listening and connective aesthetics outlined by Suzi Gablik in *Mapping the Terrain*, edited by Suzanne Lacy in 1995[10]. On the cover of this book is an ear. Listening is embedded in the book as an integral process of artistic and curatorial practice which Lacy framed under the term New Genre Public Art. Listening was intended as a key element of a relational, empathic and interactive work between the artist and the audience, thus considering art as a listening-centred practice.

But what do we mean by intersections between art and activism? How does listening relate to both politics and art practice and why is this relevant today? What is the terrain that we are departing from? Generally speaking we could say that both art and activism are often concerned with making, re-shaping and subverting things. Processes of making and doing that are not so much concerned with the production of objects per se but, in this specific intersection, with the possibility of social change. Suely Rolnik talks about this movement as an intention of what she terms "extra disciplinary" practices. She writes:

"Activist and artistic actions have in common the fact of constituting two manners of confronting the tensions of social life at the point where its dynamics of transformation are blocked. Both aim at the liberation of life's mobility, which makes them essential activities for the *health* of a society – that is to say, the affirmation of its inventive potential for change."[11]

Rolnik, writing in the contemporary context of cultural capitalism, argues that if art in its "extra-territorial drift", comes closer to activism, it is due to its own political potential being blocked. She characterises this potential of

artistic intervention as micro-political, acting in terms of sensation, performance and intensity. Activism on the other hand operates on the macro political level challenging power relations established by the dominant "cartography". She argues that the blockage is produced by the "mercantile media logic" of cognitive capitalism (that is, a capitalism centred on immaterial assets) and how it is imposed on both the inside and outside of the terrain of art. Inside, it links artistic practices to the logos of business, while outside it takes the forces of creation as a major source for the extraction of surplus value. This is the neo-liberal market logic acting on, in and around the artistic sphere. The artworld can be said to be currently operating as an embodiment of neoliberalism. Contemporary artworld structures now mimic and replicate mechanisms and values of neoliberalism such as privatisation, measurement, meritocracy, efficacy and populism. Alana Jelinek argues that over the mid 1990s and 2000s a growing accommodation and acceptance of privatisation in the form of the increasing dominance of the art market occurred within the artworld[12].

In art theory and art history the intersection between political and artistic practice has been framed, perhaps too simply, under terms such as socially engaged practice, participatory art, community art and art activism. The point at which contemporary practice is elided with activism is most often when it becomes process-based, relational, dialogic or multi-authored. One problem as Jelinek has identified, is that all too often contemporary art practices that make a claim to a politics, ethics or radicalism, actually "maintain rather than undermine the status quo and particularly the neoliberal structures that privilege and enable the few over the many". There are many clichés of resistance, like, for example claiming collaborative practice as political per se. "Just because something is done collaboratively," Jelinek remarks, "doesn't mean it necessarily

addresses fundamental issues of representation. Collaborative groups may also repress difference"[13]. And this points to a particularly slippery terrain to navigate.

There have also been other aspects of this intersection that it is worth calling attention to. In the last five years or so, alternative forms of protest to the mass march have emerged, often employing artistic strategies and experimenting with different kinds of group formations and collectivities. In the wake of the financial crash of 2008 groups such as UK Uncut found increasingly "creative" ways of protesting. This coincided with a sense of disillusionment with large-scale traditional style marches and to some extent with mainstream politics. Social movements emerged (such as Occupy) that turned away from state politics pointing to a crisis of voice in contemporary politics that might also be characterised as a crisis or at least a deficit of listening[14] on a political level. Since the peak of this wave of protest in 2011, there have been some attempts to bridge the gap with groups like Syriza in Greece and Podemos in Spain gaining seats in their respective parliaments but still with a very definitely ambivalent relationship to legislative power. Indeed it has been argued that with increasing financialisation, there is an emptying out of our democratic institutions[15] leaving a vacuum of effective politics.

"A politics of listening sits uneasily with any form of institutionalisation, whether as a party or not. Institutions tend to have rules or practices which define expectations and tune in to certain voices, but not others. Institutions are not very good at listening even when they try to do it"[16].

In *Crack Capitalism* John Holloway states that the political deficit of listening is reflected in many forms of institutionalisation. We therefore look at institutional frameworks as one of our key topics (in Chapter 5: *Institutional Frameworks*) and follow Holloway's proposal to rethink political action

in terms of "a politics not of talking but of listening, or of listening-and-talking, a politics of dialogue rather than monologue"[17]. But what does a shift from speech politics to a politics of listening imply? How might we continue to think about voice given this new perspective? How do political and artistic practices intersect? And determines the politics of listening in either of these fields?

The critical practices we choose to discuss in this book, namely the work of the activist group the Precarious Workers Brigade, the collective sound practice of Ultrared and the collaborative frameworks initiated by Ayreen Anastas and Rene Gabri, exemplify a double trajectory in terms of artists getting close to activist practices on the one hand, and activists developing "artistic" forms of political organising on the other. We would like to keep this intersection between art and activism as open as possible as in this slippery terrain between artistic practice and political practice, as there is the possibility of inhabiting diverse identities, and determine new fields of action. We won't therefore strictly apply art historical definitions to our examples but rather discuss what is at stake in those principles which have become the leitmotif of much contemporary art that borders social practice: participation, engagement and relationality (see Chapter 4: *Collective Listening or Listening and Collectivity*).

For the purposes of this book, we have introduced our examples in term of practices of listening (Chapter 1: *Practices of Listening*) to delineate something that is happening through its making and doing (and which does not separate the deed from the doing). Listening is something that is practiced, marking it out from the phenomenon of hearing. The work of the people we introduce in the following pages converge in terms of their interest and practice of dialogue and listening as relational processes (even before being aesthetic or political practices per se). There are points of departure that begin from individual paths

and feed into to a collective organism and vice-versa, and points of arrival that converge in the creation of a social space. A space, which has the ambition, the intention and the potential of becoming a political space. Here space is indeed a practiced place[18]. And the place we are embarking upon and traverse together is one that is created through this exchange of experiences, acts, and practices of listening.

Interlude... or Prelude

Claudia: Although it is most often defined as synonymous with hearing, listening is defined as an act of *attentive* hearing and it is this definition that we are most interested in. This is the effort needed to hear something, the eagerness with which we might make an effort to catch the sound of something, the stretching of an ear, with tension, intention and attention[1].

Lucia: Listening is a psychological act rather that a physiological phenomenon[2]. Musician and sound practitioner Pauline Oliveros in her writings on listening, writes that hearing is the involuntary, the continuous physical phenomena of sound waves coming into the ears, whereas listening has to be cultivated voluntarily. We can't close our ears but we can decide whether to listen or not: "hearing represents the primary sensory perception – hearing happens involuntarily. Listening, on the other hand, is a voluntary process that produces culture through training and experience"[3].

Claudia: If listening is something to cultivate in yourself there's maybe already a call to ethics here.

Lucia: In which sense is it a call to ethics? And in which sense is cultivating something in yourself an act? Is an act always ethical? I think what Oliveros is talking about is listening as a learning process, something that can be practiced in our everyday life. Ethics implies, from my point of view, a step further, some kind of responsibility. And by responsibility I mean literally the ability to respond.

Claudia: In a very basic sense, cultivating something is an act because it's something that we decide to do or not. Of course this is not always ethical, but the way that Oliveros

talks about listening is that it is about developing aware-ness: awareness of self, surroundings, of other people, of our place in the world and the universe. She seems to propose an almost a spiritual aspect that goes with the de-cision to be attentive in this way, in that it might lead to realisations, to understanding and perhaps even to a differ-ent kind of consciousness. It's not that it's ethical *per se* but there is a call that we can decide to follow or not.

Lucia: As a voluntary process, listening is the deliberate action of paying attention to something or someone, or even yourself (for instance in practices of meditation). This might not necessarily elicit a response. However, this does not mean that the effort of listening to someone without producing an answer, is necessarily un-ethical.

Claudia: No, in fact from my personal experience of being involved in peer counselling, I know that listening deeply to someone without necessarily replying can be a very pro-found and powerful act. As a listener, you can create a very effective space (and indeed an affective space) for someone to be able to speak into – to be able to work things out for themselves in. Those kinds of spaces can be rare to find and you don't always need to provide an answer for them to be created.

One of the goals of meditation is to make you more aware of yourself. A response might not be an answer, it might be for example that you allow what you have heard to change your perspective on something. I'm not saying this isn't totally unproblematic – I see some of these ideas as coming out of a counter-cultural discourse from the 1960's and one of the problems now is that any kind of cultivation of the self can also be instrumentalised in the creation of a subjectivity that is aligned to neoliberalism. At best though it is about cultivating an openness to change.

Lucia: So listening with attention and intention always implies a degree of awareness and as such can lead to some kind of transformation.

Claudia: Or at least the possibility of it.

Lucia: This could be the force of listening.

Claudia: That's an interesting use of the word *force*. It could have connotations of violence, especially of physical coercion or compulsion.

Lucia: I was thinking of *force* as potential. In Latin, the term *potentia* means both force and power. Yes, the force of listening can be misinterpreted as violent listening (for example, the use of sound in procedures of torture). This is a force we don't want! I am rather thinking of the force of listening in political terms, as the potential of listening as a way of redistributing power, reorganising power relations between who is speaking and who is listening.

Claudia: I guess we're also talking about listening's significance or value. What does listening have the power to do? To affect?

Lucia: And also its relationship to *affect*. To the physical. Acoustic perception can be considered a primordial experience, it starts by hearing the heart of the mother in the womb. "Based on hearing, listening (from an anthropological viewpoint) is the very sense of space and of time."[4] The transformative nature of listening is therefore connected to a sense of place, to memory and identity. Changes do not happen in a vacuum! The context in which listening happens and the way in which it's perceived through our body is also important. The feeling of togetherness and connectivity that listening to others or with others can create in the

subject can be also seen as a force.

Claudia: And the solidarity that this might create, that's a strength and a force that goes beyond the individual. *Force* also suggests being in command of one's powers, energies and abilities suggesting a relationship to agency, to the personal ability to do something. Perhaps even both an individual and a collective sense of agency.

Lucia: It is interesting because the expression *being in command*, make me think at some kind of imperative action (in Greek language *listening* means "to obey", while in Italian it means both "to listen" and "to feel"). So the force of listening can be interpreted both as an emotional, irrational force but also as an act of full control. When you talk about agency I suppose you mean the strength or power of the subject. But who is the subject we are talking about?

Claudia: I mean both the listener and the person being listened to. It seems to me that agency increases if we feel recognised as having value, that what you say has value; that you're given a space to speak and that it is recognised by others.

Lucia: Which relates directly to the question of who is doing the speaking and the listening and how.

Claudia: Our central question is asking what the role of listening is within the current crossover of art and activism and how it relates to politics.

Lucia: Yes, we have decided to focus on the intersection between art and activism. This can be a pretty slippery terrain, but precisely because it is quite difficult to define these emerging practices, there is, it seems, a potential for new actions to emerge. The way we are going to frame lis-

tening in relation to our examples is not in purely aesthetic terms, yet what all of this brings together cannot be entirely defined as political listening. What we are aiming to map here is the move towards action which results in principle towards some kind of social change. This force of listening does not rely, in other words, on self-referential experiences or acts (listening to listening). It is rather *listening with* and *for*…

Claudia: Social change is also a concept that can become slippery. I was once at a seminar about utopian projects called *It Doesn't Have to be Like This* at the Whitechapel Gallery. It became obvious in the discussion, that the term was losing any relation to progressive or revolutionary histories and coming to mean merely changes in the social world. So there are perhaps two kind of slipperiness we are dealing with: how terms lose meaning and become depoliticized especially within art contexts and (as in some of our cases) slipperiness as a strategy.

Lucia: We are interested in how listening can be a tool, or a strategy that makes things happen or leads to (political) action. How listening can be understood as a practice that might activate a space and a time which is not purely theoretical, experiential or perceptual, but intrinsically social and political for the reason that it sustains an "other-doing"[5]? Dialogue and voice seems very much part of this process.

Claudia: If we think about the dynamic of speaking and listening in social contexts, having your words shared with other people in a small group, repeated by a crowd, being asked a question and the answer being reflected back to you, all go towards increasing a sense of a person's ability to act.

Lucia: We are talking about experiences of listening collectively. But in what way can listening be considered a political action? Or in fact lead to political action?

Claudia: It seems difficult to pinpoint exactly what political action means.

Lucia: Yes, but if we could start from the transformative power of listening. How would you define change in relation to listening?

Claudia: I would say it is the process of becoming aware of the conditions of your everyday life and being in a position where you can then act on them to change them...

Lucia: This is what feminist consciousness-raising was about...

Claudia: Exactly, C-R was about effecting change on both a personal and a social level. This is related to many examples we will discuss with PWB, Ultra-red, and Ayreen and Rene.

Lucia: It is fascinating to look back at those political practices of the 70s and to think about what is happening now! Is there the same willingness, anger, or simple desire to change the world we live in?

Claudia: It's just a very different time.

Lucia: It seems that there are at least two ways of thinking of listening in terms of political action: listening together with others in order to become aware of your own conditions... and listening as a willingness to change them through a collective effort. This willingness can be actualised in terms of political organising, protesting, or simply getting involved in some kind of social struggle...

Claudia: I think we can go further and think of listening as a method or technique of social change, a practice for creating potential political spaces, changing decision making processes and organisational processes and therefore transforming power relations in a very direct and concrete way.

On a more metaphysical note, listening can also be thought of as an endeavour, and this evokes a journey, something to be embarked upon, perhaps even with trepidation. It is also to give heed to, to allow oneself to be persuaded by something, and I think this is interesting in terms of the possibility for opening the self to something other. We could think of listening as creating a path to travel on, as a passage or bridge[6] that we need to construct together through acts of exchange. A journey that we cannot go on alone. Listening is risky, in that it might require change from us. Change that can be painful, frightening or difficult.

Lucia: *The Force of Listening* might be a good title for our book. This could be presented as an imagined bridge, a constructed conversation that will bring together diverse voices from art, activism, art theory and political theory. We could construct this by starting with the conversation between the two of us (as we are doing now) and bring all the other voices in by following certain themes and arguments. Presented as a long conversation between us, the people we have interviewed and the authors we have read, it could be simply a montage of the transcripts, the selected quotes and the bits we are writing in between as part of our conversations.

Chapter 1: Practices of Listening

This first chapter explores the role that listening plays in the practices of our interlocutors. The constructed conversation includes the voices of Ayreen Anastas and Rene Gabri, the Precarious Workers Brigade (PWB) and Janna Graham and Robert Sember from Ultra-red (UR). Questions are raised about what listening can do and what it can produce under different conditions. What emerges is an exploration of listening as a process of transformation, creation and action. Through the relationship between these modes of listening we also start to trace something of a legacy from the political dialogic practices of feminist consciousness-raising. How might listening be used as a tool for organising? What role might it play in the formation of a collective practice? How might questions around the dynamics of speaking and listening differ in activist and artistic contexts? What might be produced and articulated? And how might this be analysed? Listening is discussed both as an inter-subjective experience and as a temporal one. How might we tune in to ourselves as well as to others?

Lucia: The main departing point for this project has been understanding listening as a social process and a political tool through the legacy of feminism, in particular the practice of consciousness-raising groups and the work of artists such as Suzanne Lacy. We are also interested in the relationships between the political and the therapeutic aspects of listening, listening as an artistic practice and psychoanalysis.

Let's start with Ultra-red. Although Ultra-red started from sound/music, as a group of sound activists your engagement with listening seems much broader than just composing: it has actually become the focus of your collective/political work. Janna, can you say more?

Janna (UR): For Ultra-red, listening isn't just about the gathering of a recording, or listening to a composition, so much as it is the organisation of the process of listening. Earlier in the life of the collective, when we concentrated on making compositions, the role of listening in political processes was not known. It was more of a record of process than an active participant. A lot of people in sound art, also in visual arts, make incredible claims for the products that are produced. As organisers we realised we were much more attuned to practices of listening, because depending on what tradition of organising you come out of – I came out of indigenous, land-based community organisation in Canada, others from AIDS and HIV, others from anti-racism or housing politics – there are protocols around listening and speaking and silence, that many of us were already sensitised to. The question of listening has been quite well theorised within indigenous, feminist and other movements. Questions like who is speaking and how they are speaking, at what moment are they speaking, and at what moment are you listening are key questions within organising spaces. When I started working in art galleries coming from a community organising context, it was perplexing to hear the curators and senior administrators speak about what the art works were doing – having never listened to what was said by those who used them in the gallery spaces. They put something into the space (the space of listening), leave the room and then endlessly talk about what it produced. Within other kinds of activism, many of us in Ultra-red also noticed this dynamic – in relation to the speech act. Someone would make a speech, make an action, with everything oriented towards the representational moment, rather than what came before, after or within it. Within Ultra-red also, this provoked a deep reflection and indeed a shift in practice, towards practices of listening.

Lucia: It is interesting, because for you it is very clear that

your experience of listening comes from activism and doesn't come from art.

Janna (UR): I suppose my first engagements with listening were certainly within community organising. I didn't come from art. I wasn't really educated within that context and often felt like a tourist in the histories and processes of the art world. Within the broader context of Ultra-red, as the group began to increase in number there was also an increase in the number of movements and struggles from which we could draw. A common point for us, has been to speak to one another around the processes of listening that take place and how we might facilitate those moments and play more of an active role in making use of the sound processes towards organising around particular questions and demands.

Lucia: So, when did you realise as a group that listening was a key point for political organising?

Janna (UR): As I entered into Ultra-red in the early 2000s this conversation was underway. Of course listening had always been a part of Ultra-red's practice before. Though we narrate this shift rather abruptly – that we used to compose and now we are concerned with questions of listening, the sounds created within Ultra-red processes were always generated and received through practices of listening. For example, the original compositions were created through making recordings in a needle-exchange in Hollywood in Los Angeles. That was how the group came together: as HIV / AIDS activists working with people who were living very precariously in East Hollywood in what was then an illegal clean needle-exchange. The recordings of the exchange were listened to and used for reflection on what was happening there – you know, in a situation where video documentation and other forms of documentation were not really appropriate. So I

think there was always a practice of listening. But there were many years when Ultra-red was much more known for performances and compositions, and where that was more of the focus. Since around 2004 there has been a much more concerted effort towards thinking about collective processes of listening and what the listening actually produces.

Claudia: The collective process of listening seems a very important element of The Precarious Workers Brigade as well. Let's ask its members what the importance of listening is for them. Chloe would you like to start?

Chloe (PWB): I suppose our trajectory as PWB, how we started to become a group seems to me very much about listening. At the first workshop at No.w.here we were collecting around the word *precarity* and what that meant individually for each of us. At the beginning we told our own stories and why we were there. We also collected testimonies... I remember creating a map using a lot of post-it notes where we wrote what the word precarity made us think about and it suddenly became something else. It became a great map of a systemic issue. Then we started to write our own particular stories and these became the material for forming working groups for the tribunal we set up at the ICA[1]. Even in the process of becoming PWB, it seems that the telling of our own stories was part of a mapping process, mapping issues of precarity. The tribunal, which involved reading out some of those testimonies and asking people to listen, also included a listening exercise derived from co-counselling. I remember that for everyone involved in this process it was quite hard having to listen to all the evidence and difficult stories, including the stuff about the ICA. So for the exercise we asked people to speak to each other and ask what those stories reminded them of in their own lives and this created a break in the atmosphere. So that the moment of active listening was also a

moment to kind of digest all of the difficult things they had been hearing.

Martha (PWB): I think that what politicized me around the issue of precarity was the tribunal and listening to those stories, recognising, I suppose, listening as a part of what can be named as active research, something that can be very generative, and results in some kind of material difference… In terms of my own experience, it was definitely one of immersion and feeling like that there was an urgency, feeling that there was a tremendous sense of solidarity even though there was a lot of complexities, not knowing whether or not it would actually happen, because it was really touch and go right up to the end. I do feel that it was important that it happened, but I feel that it has not been fully digested: even the verdicts that have been generated are still blowing in the wind somehow.

Lola (PWB): In terms of a genealogy of PWB it might be helpful to mention that prior to the tribunal at the ICA, there was a history of people gathering around groups like the Micro-politics Research Group, the Carrot Workers and the self-organising seminars at Queen Mary University. While listening was a topic discussed at one of the meetings of the Micropolitics Research Group this was simply an exploratory phase that only later developed into something else.

Claudia: Perhaps it would be interesting to hear more about members of PWB's experiences of these groups in the run up to the tribunal at the ICA.

Martha (PWB): In terms of personal experience, something that for me is really interesting is when I came to the Micropolitics group – I similarly had the impression when we were working at the ICA – that there was a united group,

which had an extraordinary intellectual prowess, articulation and reach. And I just thought, I don't belong here... I think that it is interesting what happens with groups, there was an inside and outside which was not necessarily recognized.

Chloe (PWB): I had a similar experience: I was always at the edges, I wanted to go to the meetings but also felt excluded. I was unsure if I wanted to be in it. It took a long time to get to know people and feel like I was accepted, I think. It was only in the run up to the tribunal that I felt I could be part of it...

Mila (PWB): I was thinking about the protest, because my experience was very different, I did not meet a group, I met some people from PWB at the protest. Why it was so amazing and was happening in the midst of the cuts and the mobilisation around that, was the fact that the hierarchies dissolved and those relationships changed. This is why I think actions are really important and maybe this is really a great place to reflect on why actually actions do change stuff, not just in terms of A to B to C to get there, but in term of producing a sociality, relationships, a different sense of... you know, things can get very rigid.

Chloe (PWB): Absolutely! I can just think about the Arts against Cuts weekend where I went on my own which was unusual... but there I met some people from PWB as well.

Mila (PWB): The weekend was not a familiar structure like going to a university or gallery or whatever, obviously there were some people with much more experience in organising, more confidence in speaking publicly, but I think it enabled a different way to enter that space and also in relationship to listening, different ways of engaging, in both speaking and listening.

Amy (PWB): But also in preparation for those platforms, the meetings at the Centre for Possible Studies, the Arts against Cuts, the preparation for making banners, props, cards, etc. These were small spaces within a larger group, which if you did not already know everyone, you could easily come and feel more comfortable in talking… this was very nice… also about the crisis situation we were trying to respond to. There was a moment for me where it was not clear what needed to be done and at least the group opened up that space that offered the opportunity for people to speak and listen instead of having the correct answers.

Lucia: Ayreen and Rene come from a different context, predominantly an art context. Rene what is listening for you?

Rene: If I think about it, at the risk of turning it into some kind of fetish or something, I would say probably, it's one of the main ways that I have become whoever I am or am becoming constantly… One of the main ways one can learn is just to listen to others and so one tries to invent different modes or situations of listening. Over the last years especially because of the time it takes to work on video material for example, making long interviews, I've started thinking that one almost does these things to just listen. Often we have this experience of recording something, thinking it wasn't very fruitful. Sometimes it happens in Arabic, so Ayreen is understanding all of it while I'm barely understanding. Then later we come back to the material and our perception is always very different from the initial experience of listening.

Lucia: I wonder if you can also see 16 Beaver in New York, in the same light. As someone who hasn't been there, I mean in the physical space, 16 Beaver appears to be a space for conversations and collective thinking, or am I all wrong? It is not as I understand it however just an exhibition space.

Rene: No, it's not.

Lucia: So, what about listening in that space? Ayreen would you like to tell me more about it?

Ayreen: If I think of 16 Beaver, sure, conversations are important, but if you say listening, maybe the first thing that comes to mind is listening to ourselves, listening to our intuition, listening beyond speech and language even, because that's the hardest thing to listen to, because it's more invisible, more connected to feeling rather than logos or speech or writing or formalizing. In relation to 16 Beaver, it is also listening to the city of New York, to what one wants to activate, because you also activate and listen, you want to go somewhere and listen, you want to do something to listen, we also want to listen to each other...

Rene: I often think about the notion of attunement. It is very musical and I think it has a lot to do with the whole perceptual field that listening is also a part of. Trying to attune yourself and that's why I feel... it is also the kind of opposite of channelling because I feel like we are constantly being channelled in different flows that take us away from this perceptual way of approaching our reality and trying to feel a space. Like Ayreen said, it is listening to a city, this might sound absurd but even with the work of e-Xplo[2], I think we were really trying to take the time to listen to a city and that also involved meeting people and talking to them, but really in a more expanded field where the process of listening was also the process of opening yourself up and attuning to something beyond just words and language because the world around us, the artifice of the city, all the structures and, you know, money are restricting our perceptual field, as for instance Marx said, because it's reducing your way of apprehending things through this kind of equivocation. And so the city, in a way, is almost a result

often of these kind of processes, of tearing context away, but then it produces its own context so…

Ayreen: So it's like the waves of radio that are invisible in the city. You only learn to tune in to them after a while… and those are possibly the histories of the city because sometimes some wavelengths are much louder than others and maybe less interesting for you. So you have to tune in and then get access to this other history and other people and other channels that makes the whole history more interesting. For me, and I think in New York, it's like that because if you go and only rely on the loudest streams or frequencies then you don't find what might be more interesting.

Rene: So there's a lot we can talk about 16 Beaver and trying to create such a time of listening and being heard. Even trying to develop processes of doing things together… it's a long commitment in a way…

I think it's important to try to sort out this category of listening, because it's not just something recent. Another kind of interesting reference is Benjamin's storyteller of course. He talks about the death of good storytelling which is connected to the lack of time to listen. The issue is not that there's no more people to tell stories but that there's no one to listen to them. That lack of time and space of listening to a story… there is something else that's really important, and that is connected to the story telling, which is that in the listening of the story teller for Benjamin, there is a moment of also really taking in what you have heard and doing something with it, right? And I think what Ayreen is talking about, besides the loudness of voices or histories or these kind of frequencies, is that there is an ethical dimension which is a moral to the story. One has to decide what could be done with it or how to understand it. I think that whole world of listening is very important but it's not through order, it's not that the story has an order or com-

mand, it actually requires a certain nuance and a time/space of listening through which to discover a kind of parabolic dimension, a nonsensical dimension. That's very interesting to me: it is a kind of double movement because you think, well, action should be tied to a kind of listening like orders but that's not action but automation or something like that.

Lucia: Members of PWB were also talking about action and listening.

Lola (PWB): Amy was talking about the moments before and during the Arts Against Cuts weekend and how the preparation for the protest created a space for gathering many people together. These informal gatherings were moments of speaking and listening to each other by simply doing something (e.g. making banners or flyers). I think there is a very interesting connection between listening and action here, because if we think about Hannah Arendt's idea of action (which is very much based on speech) you don't necessarily have to deliver a good political speech in order to be recognised by a group of people. The interaction between people is much more important than the ability to speak *per se*.

Martha (PWB): I think you are right about that, I am thinking more and more about the issue of paper productions. Do I really need to make more of that or can I go and just...

Mila (PWB): Just be.

Martha (PWB): I can still extract value from that work but I think that listening as creative practice can be quite potent. I need to think about the different kind of activities that might entail, but still!

Rene: The way Hannah Arendt talks about action is that it is a creation, there's a creativity and it's like giving birth, she said. That one brings something into being, she has almost a hesitancy in writing about it because she's also talking about the unforeseen consequences of what happens once you bring these things... but there is something really interesting for me, this space of listening that is tied to events/action and politics but it's not a space of order, of command or obeying, or even following a kind of a rational order. It has to do with what Ayreen was saying, another way of listening to things that are not spoken, listening to the gaps between speech, listening to silences in a room or the change of a person's voice in telling a story...

Lucia: Listening in the Greek language also means *obeying*.

Claudia: Oh really!

Lucia: Yes, but in other European languages such as in French or Italian listening means both to listen and to feel.

Ayreen: For me it should definitely relate to what Suely Rolnik calls the body knowing, to what happens when you are listening not only with the head, with the ear only, but with the whole body and how this has a different consequence for action, on what one does when the body knows.

Rene: It's tied to the porousness or the more attuned: the more you open yourself up, the more vulnerable you also become to certain kinds of sounds, let's say ways of speech or modes of articulating... but once you become more sensitive to things let's say other narratives, histories, it's also harder to withstand. If I try to explain the twenty year process of my own subjectification or process, I find myself more sensitive to who or what I can listen to. That's kind of strange because there is a contradiction of becoming more

open but at the same time through that openness you can also realize what harm can be done...

Claudia: Yeah! I have been reading the work of political theorist Susan Bickford who suggests that the opening up of yourself through listening is a risky thing because it might ask you to change...

Alex (PWB): When you start listening, you start becoming more open to stories and this can be very empowering. If I think, for example about testimonies of people who have been abused or exploited... so many different stories can build up a collective of voices which has such a strong power. It is also good for people to have an audience without being on their own...

Lola (PWB): This reminds me of the experience we had at London Occupy when we organised the workshops on the issue of precarity. I know we are going to talk about Occupy later, but what I can say briefly here is the fact that our own individual stories were changing slightly and becoming more open every time we were gathering with a new group and listening to different voices. I started for example by telling that I was living on a mix of benefits, freelance work and illegal sub-renting and one person after me said me too, specifying which kind of benefits! So I felt great because I realised that I was not alone and that more could actually be said and shared between each other. That moment was important for us because the narration that was produced in that moment was also a process of going back to our own group, a sort of re-mapping of ourselves.

Chloe (PWB): We were thinking about work and income, how they sometimes cross over and sometimes not, and somehow the differences between them, and asking these questions by going around the group was very interesting.

Lola (PWB): In a way a story empowers another story, if somebody says something that somebody else would not say because of fear or exposure, he or she will feel subsequently empowered to say more and share his/her own story. The workshops at Occupy worked very much as consciousness-raising (C-R), where listening meant listening in order to give voice, to give an account of oneself but also to reflect back on the actual conditions of the people in the room.

Lucia: In *Relating Narrative* Adriana Cavarero talks about the importance of storytelling (as self-narration) as well as of story-taking. According to her this formed the very process of feminist C-R in Italy: *autocoscienza* (self-consciousness).

Claudia: We're going to look more at feminist C-R in the next chapter.

Lucia: In terms of the artistic context, we could also go back to feminist art, to *Mapping the Terrain* by Suzanne Lacy and especially the essay of Suzi Gablik in which she talks about art as a listening-centred practice.

Robert (UR): Regarding Suzanne Lacy, a really groundbreaking work was the conversations she had with sex workers in Hollywood.

Janna (UR): We re-staged that.

Robert (UR): And just recording those conversations on an ordinary sheet of paper, and the needle-exchange that Ultra-red sort of emerged from was also in Hollywood, and a lot of it was with sex workers. So [to come back to how Ultra-red group was formed], I think the understanding of what it means to commit oneself to creating a record of

these conversations was also influenced by those early dialogues. So that's a connection. I think feminism was hugely influential on Ultra-red through the AIDS crisis. The AIDS movement that happened in the US, that the original Ultra-red members were part of, was organised primarily around procedures that feminism had constructed and created consciousness-raising processes. From the very, very beginning, this issue of embodiment, embodied listening and the collective sharing of narratives or reflections on issues of the body, was fundamental to that literal movement in the streets. The movement building, coalition building was also hugely influential, and it is part of the original vocabulary. The conditions of contexts and the investments in listening collectively were already in place. So there is a direct lineage from feminism, through the AIDS movement into Ultra-red's practice. And of course the very deep and long alliance between feminism and the queer movement, gay and lesbian struggles. The intersectionality of these struggles that feminism also pioneered is a huge part of those sort of politics. Already the foundation was in place and there was a sort of a legacy. Ultra-red is immersed in those practices and those literacies of coalition building, of collectivity, of the intersectionality, of the personal politics with the collective analysis of the political economy.

Lucia: It seems that a common thread between your work and PWB's practice is a focus on process, listening as a process and not as an end. There is also the importance of analysis which was another central point in C-R groups.

Chloe (PWB): The link I can see with C-R groups is definitely very much with this idea of working from personal experience in order to analyse a much bigger situation.

Lola (PWB): That for sure is something that we did with the tribunal at the ICA but we also continued to do with

workshops and other activities based around facilitation.

Janna (UR): In both cases (Ultra-red and PWB), this focus on analysis also comes from engagements with popular education. Originally when I first met and worked with Ultra-red I remember thinking we had come together because of a shared interest in sound. But when Don and Leonardo (who are both from LA) first came to Toronto where I lived at the time, I took them to my favourite place, a popular education training and publishing space called the Catalyst Centre – a truly amazing place that translated popular education processes from Latin American and indigenous communities to activists in Toronto. It was very much informed by migrants from Latin America who came to Toronto in exile from military dictatorships, and they brought especially people from Nicaragua who brought their experiences of militant literacy training. Don, Leonardo and I were standing in this place and we realised that actually there was a very significant history that brought us together which is not actually from sound, or not only about sound, but rather from our shared histories with radical education, which prioritised practices of listening. So this idea of the object not being the end comes out of that for me. If you read Freire and others from these movements carefully, cultural objects are produced for the purpose of listening to one another while formulating an analysis, which in turn is moving towards the process of emancipation, of change, of transformation. The idea that neither sound-making nor listening are an end, but part of a generative cycle was significant for us to articulate. Our engagement with psychoanalysis also aided us in this… the idea that listening isn't an end, it is also part of an ongoing process of analysis.

Robert (UR): I think, psychoanalysis has crucial importance in our work. It is connected with beginning the fundamental process or the necessity of translating listening into lan-

guage. Critical to the psychoanalytical process is articulation, so that just the process of co-listening is insufficient. There is a lovely moment, it's not aligned, but I think a very productive one, which Freire would call the codification, which is the importance of being able to articulate experience and analysis in a kind of representation, in an object, in order to be able to have a common point of reference for the next phase of the analysis. So in psychoanalysis the construction of a kind of codification in language that is manifested through the transference, represents a critical necessity to collaboration. That is very important too.

Lucia: While talking about feminism you have mentioned intersectionality, can you explain how this might be linked to the notion of inter-subjective experience which comes from phenomenology?

Robert (UR): So language as a necessary medium for listening is something that is very crucial. And this is where the critique of phenomenology is of course very important, because it becomes individualised. Having said that, I have to say that I'm somewhat invested in figuring out how we can kind of reclaim phenomenology. This is where I make a big distinction between Husserl and Merleau-Ponty. Where Merleau-Ponty articulates a phenomenology that is clearly informed by the emergence of European communist movements, and particularly '68, the shift in Merleau-Ponty's work after '68 into a kind of intersubjectivity in phenomenology, in what he calls the intertwining, that to me opens the space of the political within the phenomenological. Experience for him is basically simply a discovery of a knowledge that feminism already had discovered. And the particular way in which feminists had amplified this aspect of psychoanalysis was inter-subjectivity. Psychoanalysis was conventionally founded on the ear of the analyst as being the point of enlightenment or sort of power. Whereas femi-

nist psychoanalysis saw both the analyst and the analysand as in a process of radical transformation that meets at this point of inter-subjectivity. So listening is always through the ear of the other. And I think Merleau-Ponty's phenomenology creates the opportunity for that intertwining that is about the necessity of an inter-subjectivity. And I think Merleau-Ponty was deeply informed by this notion of the split subject, which of course is one of the emergences of psychoanalysis and critical to the foundation of the political feminist psychoanalysis. The always already formed relationship to the Other.

Chapter 2: Feminism – Speaking and Listening in Feminist Consciousness Raising Groups

It seems pertinent now to devote a chapter to feminist consciousness-raising as a practice. Feminist consciousness-raising groups (C-R groups) exploded among women in the late 1960s. They were an integral part of the feminist movement spontaneously forming across America and other Western countries. "By 1972 every block in Manhattan had at least one consciousness-raising group"[1]. The term *raised consciousness* refers to becoming conscious of something which one did not perceive before, of something being raised from the unconscious to the conscious mind. As a tool, it was adopted from the Civil Rights Movement in the 1960s, where it was known as "telling it like it is"[2]. C-R groups were very specific small women-only groups organised to share experiences related to sexism, acknowledging in particular that it was important to break women's individual isolation and silence. It was also important that they were not public arenas but women-only spaces created in order to make it safe for them to start speaking about the conditions of their lives. In *Man Made Language*, Dale Spender argued that women were in many ways outsiders to a language that was not of their making and in some ways borrowers of the existing language. C-R groups were therefore places for women to start to be able to name a problem that they did not have the language for before. Places where women were able to start "to deconstruct their muted condition"[3]. As the Milan Women's Bookstore Collective summarised in their account of the Italian experience, C-R was:

"a social site where women could talk about their experience and where this talk had acknowledged value [...] women no longer conformed to other's opinions [but set up a space to be free] to think, say, do and be what they

decided to, including the freedom to make mistakes"[4].

Rather than any attempt at providing a wider and exhaustive analysis of C-R groups, this chapter re-traces the relationship between speaking and listening in feminist political practice through the personal accounts of Pat Caplan and Anna Sherbany.

Lucia: We would like to start this conversation by asking you about your experience of C-R. Given that neither I nor Claudia took part in a C-R group for obvious age reasons, we are particularly interested to go back to the basics, how the meetings were organized, how they started and so on. Also, given the topic of our research: listening at the intersection of art and activism, we would like to know more about the process of listening in C-R.

Anna: Well, the main thing was actually talking, so I wonder why the notion of listening?

Claudia: There is often a lot more emphasis placed on speaking, whereas in *Man Made Language*, Dale Spender talks about listening being as important as speaking, in order to create the speaking voice.

Anna: I think it should be more like *listening to*, not just *listening*. There is a difference between the expression *speaking to* and *speaking with*… but this difference is not present in all languages… The common idea of listening, or what I thought about listening, is the fact that I associate it with passive listening, a kind of religious attitude… however, the women's group was not about listening, it was about talking and being listened to.

Claudia: This is a really important point especially in terms of gender – listening has sometimes been seen as a femi-

nine attribute associated with passivity. We are more interested in listening as being active as well as being reciprocal to speaking, so perhaps we should think more of it in terms of *listening to* or even *listening in order to*, to indicate a move towards action. How did C-R start for you Anna?

Anna: I think it started as a reading group...

Claudia: Pat, you also mentioned that yours started as a reading group.

Pat: There were a lot of different groups. For example I belonged to a local women's group which looked at certain texts such as Simone de Beauvoir's *The Second Sex*. It was around the late 60s, beginning of 70s. All the women in the group had partners, husbands, and several were new mothers. We were all highly educated... I think the women's movement grew up in part through other movements, for example the civil rights movement with educated women... there were also some key texts such as Betty Friedan's *The Feminine Mystique*, a book that really touched a raw nerve!

The movement latched on to a feeling of discontent because we came from the end of a period (especially in the US and in the UK as well as in other parts of Europe) in which women had been discouraged from working. My mother had a paid job but we were forbidden to talk about it as it was considered a secret.

A bit later, I also belonged to a group of women anthropologists all of whom had or were about to get their PhD. None of us were employed, while the male peers were getting jobs... Anthropology was hardly considered a women's thing, it was extremely androcentric, so for me that group was extraordinarily important because we were all really determined that we wanted to change the way in which our profession was run, the theory, the literature,

the name. Finally, the other group I was involved with was focused on the Feminist Library and the interesting point about this group was the fact that we wanted to work in an inter-disciplinary way.

Anna: For me it started by talking to the women in a kibbutz in Israel… then in the early 70s with a women's group in England. My women's group was about sharing things, talking about issues, for example: babies, monogamy, orgasms. I remember that there was a lot of giggling and lightness talking about orgasm… In a way we were counselling each other on a small scale. There was in fact a lot of support: there was no way that a woman was going to a hospital by herself!… The women in the group were straight, no lesbians, however there were a lot women with a double trajectory, experimenting with this… what we can call "political lesbianism".

Lucia: So what was the difference between C-R groups and other activist groups?

Pat: I think it was very powerful because compared for example to other activist groups like the Labour Party or the Anti-Apartheid movement, the feminist groups were very clear that listening was crucial and people should listen attentively because everybody had the right to speak and should be encouraged to speak. For me that was very formative. In my experience as a university teacher, I did not want seminars dominated by a few people, so trying to get across to students as well, was a very important way of communicating, as we could all learn from each other.

Lucia: If I understood well from what I have been reading about C-R meetings (for example Carol Hanisch's text *The Personal is Political*[5]), they were organised according to a set of rules or protocols, namely going around the room and

listening to each other's stories, taking turns in proposing a question to be discussed, summarizing and making connections between the personal accounts brought by each woman.

Pat: I have never heard them called protocols before! The ethos was that people got listened to. Obviously with a small group we had sessions all together while with a big group we normally broke up in small groups and reported back. This was a good way to handle a lot of people...

Claudia: Anna, was there any kind of facilitation in your group?

Anna: The group was not very big, about 10 people, so this was not an issue. The way it worked was very much based on choosing a particular element that had been denied us, then working on that and finally taking the issue back to society. There was a lot of awareness of people being included, to move around the room in order to include everybody. Based on egalitarianism, this was a direct result of the feminist practice...

Claudia: According to Kathie Sarachild[6] there was no one method and while there have been a number of formalised rules or guidelines for consciousness-raising, what counted were the results rather than the methods. She says that the purpose of hearing from everybody was to build a picture of what was going on, to get a picture of how the oppression was operating, to analyse the situation and conditions, not to analyse individual women. Greater understanding of the situation determined what kind of action, both individual and political, was needed.

Anna: In our group the aim was to give the women voice. When sitting around, the guys, they knew that they had to

give space to women to speak as well...

Claudia: Do you think the fact that it was a single sex group changed that?

Anna: Yes of course, this is what it was all about! It gave us a space to talk, it gave us a language to talk with, it gave me the confidence to talk in a space like that, also it encouraged me to talk about things that otherwise I would not have talked about. This made us feel that we had the power to achieve things, to have the right to do that and taking the message to the people we were working with... Sometimes the lines were not very clear but the separateness had to be taken on board, the guys absolutely had to take on board that it was our time.

Pat: C-R groups were really powerful, very transformative. It was a huge amount of energy, I can't tell you how energizing this all was. We did feel things were changing, hopefully for the better, that we were making history in a way... I don't say that they were all sweetness and light because they were not. With the academic group, for example, it was not such an issue because of the fact that everybody was an academic but in other groups where you had people with different levels of education you had some people who were more articulate than others. So one thing I learnt is to listen to the less articulate people carefully, because they had a message too and they needed to feel comfortable.

Anna: We were being listened to, we were listening to each other, that was the whole idea, but in order to be listened to, we were also learning to talk, to articulate things, to find the language...

The women were also giving up their last names, their father's name and trying to find a name that suited

them. This process of un-picking was a very important part of dismantling patriarchy, taking other positions, creating a language, finally recognising the way in which society was structured to keep the women in the position they were in… The de-construction moment came about when we asked ourselves who we were and what our capabilities were. There was a lot of talking about self-confidence and assertiveness training which was literally lifting your head up.

Pat: To go back to the phrase *the personal is political*– it was very important to realize the different kind of problems we had including work, children, paid wages etc. There was a lot activism around working conditions… and what it enabled was that feeling that women's problems were not individual problems but they were collective. Particularly because I am social scientist, immediately it made sense to me that we did not look at a series of individuals. At the same time it was important to enable individuals to work through issues that they were having in their life and the conflicts they had with themselves. I think C-R made a big impact.

Lucia: In her article *The Personal is Political,* Carol Hanisch defines C-R as "political therapy", what do you think about this?

Pat: Of course it was a kind of therapy, but it was about getting involved in things and not saying "poor me"!

Claudia: Hanisch talked about this practice of political therapy both as a way of getting rid of self-blame and feelings of inadequacy and as a process of collective analysing. I am curious to know what happened to the knowledge that was produced by the groups, if there was a kind of analysis, how did it feed into changing things?

Pat: I suppose it fed into people's lives. The local group, for example, helped people to do different things if they wanted to change a situation. There were also demonstrations. A lot of us were also involved in other things as well, like for example the miners strike.

Lucia: Hanisch also says that the practice of gathering women together and giving voice to everybody was not considered by some women to be a political action in itself. Do you think that was true?

Pat: I think for many groups it was not considered as part of the action but later it became so and it was organised around particular issues. The Women's Liberation Movement had an increasing number of demands, for example equal pay, child care, nursery, etc. Nothing has moved on! Other women were involved in other issues, the issues around Greenham Common were for example a big focus. Others instead did go into the labour force, so they had to face the problem of managing their lives... A lot of women I knew including myself went into the labour market so it was hard to find time for regular meetings, going to women's conferences and all the rest of it... Going back to the kind of groups that started in the early 70s, some of them were very local and that was very good because you got people from a particular area/neighbourhood who were able to support each other in a different kind of way.

Anna: The disappointment for me is why this all disappeared. A big issue was the issue of class. The Women's Movement fell apart in a way, and the issue of class was a part of it...

Pat: Many women involved were middle class, many had schooling, and most of us had degrees. It was rare to see working class women involved in these groups even

though middle class feminists were involved in working class issues such as housework. There was also the issue of ethnicity and race, as well as the issue of being in solidarity with men. The question was: what do you put first, the issue of feminism, or being black or being working class? Gradually it all became more complicated as people realized that there were inter-sections, it was not just about being a woman, or what women were about. In the late 80s, early 90s, there was also an interest in masculinity because of course you have to look at gender relations, and the fact that masculinity is also constructed.

The basic question was what feminism meant to us. This is my favourite definition, it is a quote from Rebecca West: "I myself have never been able to find out precisely what feminism is: I only know that people call me a feminist whenever I express sentiments that differentiate me from a doormat"[7].

Anna: In retrospect, I am aware that the issue of race was not dealt with… if I think about my situation of dealing with racism. It was about women and then gradually it become more problematic. It was somehow evolving and although I felt there was something wrong I was not aware of exactly what it was.

Pat: I think it has to be seen in the context of what happened in the march of capitalism and consumerism, and what happened to politics in a number of western countries, I mean politics as in parliament, parties etc. There is no doubt that there was an enormous disillusion in most countries, particularly among young people, with conventional politics. We left the Labour Party with huge disgust with New Labour. And of course we had 19 years of Thatcherism.

Lucia: Some of this disillusionment towards conventional

politics led to Occupy which I know you were involved in to some extent (as were a lot of our other interviewees). We will discuss Occupy later in the book, so I want to go back to listening for the moment and ask: what might collective listening be for you?

Pat: What about value-added… [laughs!] In other words collective listening is more than just dialogue between two people, it develops as a kind of entity, a body of communication in which people are both listening and reacting. I think the best listening is not only when you listen and you reply in that space and time, but also when you go away and think about it afterwards, so the response could be immediate and also it could be years later.

Claudia: What about you Anna? Do you think we could reframe C-R in terms of collective listening?

Anna: As I previously said, C-R was not about collective listening, it was about talking and listening as a whole activity, having a space where you feel that you can say what you have to say, and therefore other women are saying what they have to say. This really has an importance, it is actually relevant. It is similiar to working class history, "telling" what is going on with your own life is important. In any of those collectives there is an element of minority, an element of the voice that has not been heard. I have to say that C-R worked for me, it bloody worked!

Lucia: In terms of identity politics the impact of C-R was crucial as it created a new political sphere in which women felt fully recognised outside the patriarchal order. As we heard from Pat and Anna, the women-only group created a space for collective thinking in which it was very important to twist and deconstruct the language of patriarchy and start to think how to move forward. If we are thinking

about tracing a legacy of C-R in terms of listening practice, it might be helpful to focus on two aspects that have become clear through this conversation: the question of the personal experience versus the collective, and the notion of political therapy. As Anna suggested "collective listening" might be a misleading concept for understanding the legacy of C-R groups. They were not sessions to create a common space for merely developing certain listening skills. It was more than that.

Claudia: Yes, I'm interested in Anna's association with listening as passive. I like what she said about it being *listening to* rather than just listening. In *Man Made Language*, Dale Spender questioned the association of listening with passivity and wondered whether there was a bias in terms of listening being a skill that was associated with the feminine (e.g. listening is something which women do more than men, or are "better" listeners) and therefore mistakenly also associated with passivity. She poses an interesting question: "Is there any connection between the devaluation of women and the devaluation of listening?"[8] At the time that she was writing (in 1980), there had been very little research done on listening and she wondered if this wasn't why. I also really liked how Pat described what developed through the listening of C-R as an entity, a body of communication.

Lucia: The issue of time raised by Pat is crucial: the time for listening to each other's story, opinion and personal experience, and the time necessary to react and articulate more than a collective answer. What the feminist movement has produced over the years, through and after the experience of C-R groups, is to empower women to take a position and organise themselves collectively through new autonomous initiatives such as women's libraries, health/research centres etc. (e.g. the Milan Women's Bookstore Collective).

We could say that listening has been practiced in order to speak differently and to speak about difference. And here the word *difference* is vital not only for remembering the varieties of C-R groups active between the 60s and the 70s, but primarily for a new mode of political organising informed by the practice and theory of sexual difference. To look back at feminism as a genealogy that contrasted dominant systems of male power and their vertical organisation means also to look at C-R groups as an example of small informal groups independent from political parties and, in some cases, from the radical left. They introduced a model of micro-politics based on direct action and they can be seen as the ground for feminist activism.

Claudia: Yes, but not only for purely feminist activism, the model that C-R groups developed has been a ground from which all sorts of kinds of activism has emerged. The organisational aspect of the groups is very interesting. They were very much based around anti-hierarchical, more horizontal and even anarchistic ideas of group formation. What I also find interesting is how their relationship to the larger women's movement changed. As small groups dedicated to raising consciousness of individual members they worked well. However at a particular moment there were concerns about how politically effective they were. According to Jo Freeman a shift from C-R as an end in itself to a more organised phase was seen as a necessary step of the women's movement. Women's liberation had become a household word with many of the issues being discussed in the public arena. Consciousness-raising as the main function of the women's movement was felt to be becoming obsolete. In Freeman's analysis, the unstructured groups that had been formed in reaction to rigid structures of society had their limits – they were politically ineffective, exclusive and discriminatory for those not tied into the friendship networks or fitting into the group characteristics. She ar-

gues that they were very effective at getting women to talk about their lives but not so good at getting things done. "They flounder and people get fed up of just talking – the informal structure is not enough to enable people to operate effectively"[9]. In fact many women turned to other political organisations that provided the structure they were not able to find in the women's movement. I assume she is talking here about trade unions and other leftist political organisations but she doesn't specify.

Lucia: The history of the women's movement is complex and certainly has its own contradictions. I don't know so much about the history in the UK and in the States. But if I think for example about the history of the Italian women's movement, this was characterized by the widespread phenomenon of a *double militancy*. While a number of women continued to work within the parties of the Left for women's rights and social equality, achieving major social reform such as the legalisation of abortion in 1978, they also continued to take part in C-R groups. And while most of the C-R groups dissolved in the late 70s, others continued and developed into other forms of social organisation. From 1976 the so-called "practice of doing" among women began to spread. This is particularly evident in Milanese feminism, where it takes the form of "downright experimentation, opening up within society the separate spaces, places and times of an autonomous female society"[10]. Because of this, it could be argued that the women's movement differs from other Italian political movements of that time in that it rapidly changes its practices[11].

Claudia: I think this model of flexibly changing and shifting strategy is something that is also happening within recent social movements such as those organised around anti-globalisation for example.

What interests me about what Jo Freeman writes, is

the main concern that through the lack of organised structure within the groups, informal structures, elites or hierarchies often surreptitiously emerged. As a consequence of this, C-R groups stopped from properly practising equality. As both Pat and Anna were saying, issues of class, education and race often existed within the groups without being properly addressed.

In the larger movement there was also an issue with "stars", people that emerged who were latched onto as representatives of the Women's Movement even though it had consciously decided not choose spokespeople.

Lucia: How did things develop?

Claudia: At the beginning, the small, leaderless unstructured groups were the sole form of organisation of the women's movement. While at first, the personal insight of the participants that the supportive atmosphere of the groups produced seemed enough, it was later felt to be limited as a vehicle for wider socio-political change. The question was how to make the movement more politically effective. The desire for meaningful political activity, that the women's movement didn't seem to offer an outlet for, at that particular time, led to a rethinking of the stance towards structure that it had previously eschewed. The question of how to organise more towards action as well as how to deal with unintended hierarchies and larger groups created the necessity for more formalised structures of decision-making and what we might now call "protocols".

Lucia: Consciousness-raising groups introduced more horizontal modes of organising compared to dominant systems of male power and their vertical organisation.

Claudia: Yes, Dale Spender also writes about how in C-R groups the speakers often rotated in order to create a more

co-operative and egalitarian structure for speaking. That co-operation rather than competition or domination were valued and this meant people being willing listeners as well as willing speakers. When they worked well, the groups encouraged trust, co-operation, collective consciousness and also independence on behalf of its members, helping women to feel that they were both individuals and members of the group. However many groups felt that they needed guidelines in order to facilitate this equality of speaking. There was a realisation similar to that of Freeman that everyone had been socialised into inequality and this caused difficulties in creating equality within a group. Equality could not be assumed.

Dale Spender saw the potential of the challenge to hierarchical structures that these horizontal modes of organising posed and the important role that listening had in this. She argued that because talking was seen as an opportunity to understand the views of others and not just hearing one's own, this might lead to profound changes, particularly to hierarchical structures which generally promote the talk of the few and the enforced listening of the many. "If listening were shown to be as important and as complex as talking, if it were shown to be equally valuable, there would be repercussions in all our social institutions. Educational theory, for example, along with political practices might be transformed by such an understanding"[12]. One of the legacies of these debates within the women's movement has been a growing understanding of how groups operate, covertly as well as openly, while another is the development of consensus decision-making processes.

Lucia: I wonder how ideas of political therapy can be inserted here and how this is linked to listening.

Claudia: As we saw with our discussion with Anna and Pat, there was a lot of debate at the time about whether con-

sciousness-raising was political or therapy or both. Anna suggested that C-R was a kind of counselling, in terms of the support that was generated.

Lucia: This reminds me of what Carla Lonzi wrote in her diary. She wrote: "the *autocoscienza* (self-consciousness) of one woman is incomplete and remains blocked if is not reciprocated by the *autocoscienza* of another woman. Every woman needs space because her moment is manifesting herself and not listening. Listening is important but its final goal is to talk about the self".[13]

Claudia: I think that the work on the self was important but only part of the picture. The term *therapy* was quite often used as a putdown for the groups and the reason why they were not seen as political. Carol Hanisch explains this through the way that therapy can assume that a person is sick and that there is therefore a cure that necessitates a solely personal solution. Hanisch coined the term *political therapy* to indicate something different. And while we saw that there were very definitely personal aspects to C-R, the supportive atmosphere, gaining personal insights, getting rid of self-blame and learning to articulate the conditions of the participants' individual lives, the groups could also be seen as analytical sessions that were a form of political action, a beginning point to start to change the objective conditions they were living in and not just as a means for women to adjust to them.

Chapter 3: Towards a Politics of Voices

In order for any dialogue to take place, there needs to be both speaking and listening. We saw in the previous chapter how C-R was very much connected to finding a voice with which to speak and listen to. In this chapter, we look at critical theory which might shed light on listening as a relational and social process through an investigation of *voice*. Voice can be separated into three strands: the vocal and physiological, emanating from the body; as a mode of self-expression; and as a connection to politics through democracy (that is, as defined as votes given in parliaments or assemblies or the issuing of commands, dissents or protests). By thinking about how these three aspects of voice are interconnected or affect one another we might also be able to think more about the role listening might play. This constructed conversation features media sociologist Nick Couldry and philosopher Adriana Cavarero[1] who both come at voice from slightly different perspectives.

In *Why Voice Matters*, Nick Couldry argues that *voice*, defined by him as giving an account of one's self, is the only value that can truly challenge neoliberal politics. However, "having voice is not enough: we need to know our voice matters [...]. *Voice* does more than value particular voices or acts of speaking; it values all human beings' ability to give an account of themselves; it values my and your status as 'narratable selves'"[2]. By thinking of voice as a process of giving an account of oneself Couldry proposes a challenge to neoliberal culture which reduces political and social interactions to purely economic relations with the market. This challenge resonates – as we will see in the following chapters – with practices of listening that embrace the process of registering voice as a mean of recognition and social interaction.

Adriana Cavarero's work deals with voice at the intersection between vocality and the political. In her book

For More than One Voice, Adriana Cavarero posits a new relationship between *logos* and politics. This is one in which voice is not about speaking in order to hear the self, but is deeply relational and bound up with the Other. She is highly critical of what she sees as the solipsism of both traditional metaphysics and Derrida's critique and deconstruction of speech within it. Cavarero argues that the history of metaphysics has constructed a system that neglects uniqueness and relationality with regards to the voice. Her strategy is to overturn the old metaphysical approach that subordinates speech to thought and emphasise that speaking means "to communicate oneself to others in the plurality of voices". According to metaphysics once the voice is taken away from language as a system of signification, it becomes meaningless. Cavarero looks to that part of the vocalic that is in excess of language, over and above the linguistic system. This is the phatic function of the voice, the "I am here", communicating the singularity of an existent being in flesh and bone, signalling a body subject to another. This is what she calls the "vocal ontology of uniqueness"[3].

But what does it imply to shift from the term *speech* to *voice*? How might we understand the voice's relationship to language, signification and the body? How does feminist theory represent a key reference point for understanding the political dimension of dialogic practice? Might narration and/or storytelling be understood as a political act? We look at different ways in which we understand the political and how this affects our understanding of voice. Is the act of registering voice always political? Does listening to voice necessarily mean attending to sound? What are the political implications of paying attention to vocal expression, to vocality? At the end of this section we return to questions of listening in light of what we have discussed. What might listening mean in relation to the political? How should we listen?

Claudia: Nick, can you tell us a bit about the rationale behind your book *Why Voice Matters*?

Nick: The reason why I wrote the book was that a sense of voice is everywhere, everyone's got a voice but it is everywhere and nowhere, it's not mattering. The title of the book was meant to be called *Voice that Matters*, after Judith Butler... of course it's obvious why voice matters, but the point is, does it matter? What stops it mattering?

Lucia: Towards the end of your book you talked about listening as a way of thinking about political exchange, in order to listen better to citizens and for citizens to listen better to each other. It seems to me that the way you have framed voice is very different from a phenomenological perspective in which listening (to voice) merely equates to (the experience of) listening to sound. A cornerstone of sound studies is of course the work of Don Ihde on the phenomenology of voice and listening[4], which you have discussed in your chapter on philosophies of voice. In my opinion, the tendency to equalise voice to any other sound phenomena, seems to have diminished the social and political dimension of both voice and listening. I can think for example of a lot of sonic experimentation in which voice has been treated as a pure sound object. I wonder if your proposition of valuing voice also means valuing listening as part of a whole project of rethinking politics.

Nick: In my view listening is not attending to sound, it's paying attention to registering people's use of their voice in the act of giving an account of themselves. This is clear in art because giving an account can take any kind of form: it can be pasting a photograph on a wall, a graffiti, a walk through a space... It cannot be reduced to sound, and is not about the sonic wave or the way in which we use our voice to make sounds. One can easily show that this is too

limiting because if we imagine a group of deaf mutes who use sign language to make an important political intervention, nothing is heard, but no one would say for one moment that's not voice... So it's very important that it is not about sound, however it is about listening. The word *listening* stands in for that wider act of registering others' accounts for ourselves... and I think the political edge of voice becomes clearer when you move to listening. There is some interesting work done about listening which I knew nothing about until some Australian writers suggested the work of political theorist Susan Bickford. I don't know if you know her book. It is the only book in political theory about listening. In political theory and political science there is quite a bit about speaking, voice, voting obviously. Listening should be the main subject of democratic political theory but there is nothing about listening, nothing!

Lucia: In the book you have also talked about voice in terms of process and embodied experience. Besides the reference to Judith Butler's notion of *giving an account of oneself* you also draw from Adriana Cavarero's understanding of the human being as a "narratable self" (from her book *Relating Narratives*[5]). The ability to register voice, on one hand, and provide multiple narratives, on the other, appeals directly to us because listening and storytelling seems a crucial point for the work of the artist collectives and activists we have talked to. I wonder however what the difference is between a literary and everyday narrative, and to what degree this reflects a *human status*.

Nick: Well, I think that's a difficult question because obviously we now understand a lot more, than was understood say in the early '60s, about art as a process... so that's one thing that raises the question. Is there anything essential about the form of narrative? Although Paul Ricoeur talks a lot about particular narratives and novels when he's talk-

ing about narratives in general as a human value, I don't think there is anything essential to its form. It is the practice of an embodied being going on giving an account of itself, carrying memory, projecting into the future, trying to make one fit the other, trying to be adequate to what one knows about one's past and so on. It is this endless dialectic between all these temporalities. When you transpose this to the group, there becomes a problem because we don't die as a group, we don't struggle for survival as a group. We each die individually, so we have to respect the individual voice within the group, on the other hand, we also have to build things together. So we have to think about that process of building narrative together that respects the separateness of each voice that enters but at the same time tries to respect it and allow something bigger. Ricoeur doesn't believe there's any simple completion. He says that at one point we are all entangled in each other's narratives. So this struggle to think about the collective process is fundamental to what voice is, unless you misunderstand it and think voice is just about neo-liberal individuals.

Lucia: This point about singularity within plurality, resonates very much with Cavarero's proposition of re-considering uniqueness in relation to voice. Her perspective is that valuing voice is not however just a pure metaphor but the actual process of valuing the vocal part of *logos*. The voice, she says, "is sound not speech [...] but speech constitutes its essential destination". And according to Cavarero it is a prejudice to think that outside of speech voice is nothing but an insignificant leftover: "Precisely because speech is sonorous, to speak to one another is to communicate oneself to others in the plurality of voices"[6]. In a conversation about her book *For More Than One Voice*, I asked Adriana Cavarero about the relationship between voice and uniqueness. Adriana, could you say more about your notion of vocal ontology of uniqueness?

Adriana: I have been interested in the theme of the ontology of uniqueness for a long time now. I arrived at this theme through two influences and trajectories: the first one is what we can call feminist theory, or feminist philosophy. Feminist theory is incredibly diverse, however it does have one common point which is the critique of the absolutism of the subject. In philosophy this critique does have many different names: we could call it *antropos*, I, subject, ego. According to Hannah Arendt all these names are "fictitious entities". And this is the second influence, Hannah Arendt, who insists very much on uniqueness. She says that the real subject of politics can only be the agent in action (*l'agente mentre agisce*). The action itself expresses the embodied uniqueness. So by intersecting these two influent trajectories, the uniqueness from Hannah Arendt on one hand, and feminist theory on the other, my research focuses and insists on embodiment, on the body. Vocal expression is therefore an expression of flesh and bone, yet it is not merely matter because it is actually communicating matter.

In my book I argue that vocal expression (*la vocalità*), is the communication of all communications because… if we think of the language (at the level of discourse) as the privileged form of communication, what it does communicate is above all the uniqueness contained and expressed through the voice. Voice is the most important form of communication and for this reason I focus on it in my writing. To make an example that is easy to understand, we can think of the communication between mother and child. Here the communication does not happen in terms of *semantikè*, it is not about rational articulation, logical speech, but it is a vocal communication. Vocal expression is a very important form of communication because what we learn from a mother tongue is not purely a grammar, a structure, a syntax, a logical system, but also a wide vocal range.

Lucia: So what you mean by vocal expression, by *vocalità*, is the possibility to understand voice not simply as the acoustic component of language as a system of signification. Can you tell me more about this vocal part of *logos*?

Adriana: We can go back to Aristotle who said in *Politics* that *logos* is *phonè semantikè*, which literally stands for "meaning voice" (*voce significante*). Thus there are two elements: the *phonè* which is the phonic part of *logos* – which I prefer to call *vocalico* (from Latin *vox*, voice); and *semantikè*, a term that can be translated in many ways, but which we could translate here as a structure of signification. According to Aristotle the *phonè*, the vocal part of *logos*, is the human element which still belongs to the animal world, to *zoe*, so what distinguishes the human being from animals is the *semantikè* and not the voice. So from this point, there is a devaluation of voice. My particular thesis argues that the whole history of philosophy has constantly tried to eliminate the vocal part of *logos*, in other words, its most expressive part, making *logos* a system of signification, which is universal and abstract. I argue that the vocal or phonic part of *logos* is always expressed by a mouth, by a unique singular living person. Therefore, the vocal element is the part which cannot be universalized as it belongs to a particular body or subject.

Lucia: In your book you often use the term musicality, what do to you mean by it exactly? Intonation, timbre…?

Adriana: Intonation and the grain of the voice, what Julia Kristeva would call the semiotic, which is strictly linked to the body of the mother. However, if I had to summarize this concept, to make it into a word, I would say that it was rhythm… which is about vitality and life. Our breath is rhythm, our heartbeat is rhythm, the first crying is breath and rhythm, every spoken language has a rhythm, and ev-

ery voice has a rhythm. Rhythm is a vital element. Voice is therefore about breathing, about life. So another characteristic of my research is to focus on this category of life and not of death. And this is something that I inherited from Hannah Arendt. Voice for me does not mean simply vocal expression through the throat, it also means acoustic reception because voice is communication. It is both emission and listening.

Lucia: In your book you have used many examples of female figures within myths to present your arguments. Is there a particular reason for this?

Adriana: This is a method that I have being using for many years. It is my way to carry out a certain feminist theory or a feminist thinking…

Lucia: Is the revaluation of voice in terms of vocal expression something that belongs solely to feminist theory?

Adriana: Not only the feminists, this is an old theme that both Plato and Derrida talk about. Plato says that the true discourse is the spoken discourse and not the written discourse because while I am speaking I am able to defend my point of view, something that I can not do through writing. He said that the written discourse is the "illegitimate child", the child that becomes an orphan… This platonic rationale does however have a trick. Plato does write dialogues, therefore he opts for a particular form of writing which resulted in one of the most brilliant examples of writing that overcame oral culture. This is why the connection between abstract philosophy, writing and metaphysics is, in my view, very close. In opposition to this story there is also another one that can be followed. This is the story of voice, communication, singing, poetry and vocal performance, which all imply a stronger bodily and communicative presence.

I should perhaps say that my book is also a polemic with Derrida and his phonocentrism. Derrida says that from Descartes onwards the characteristic of *logos* is about the presence of one who can talk and at the same time hear himself talking, therefore an entirely narcissistic concept of the subject who talks to himself. He is both the subject who emits the voice and the subject who hears himself. This is a confirmation of the self: my existence can be proved from the fact that I can hear myself talking. According to my view, this is a very male, abstract metaphysical concept because the voice element and our vocal performance are not made for hearing ourselves speaking, but to communicate with the Other... The way in which Derrida presents metaphysics as a self-referential figure of vocal expression results in my view as a monologue, but this is not common practice in life. We don't live through monologues! We live through conversations and dialogues.

Lucia: So what might it mean to enable different voices? I found the difference between plurality and pluralism you made in the third part of the book where you talk about a politics of *voices* very interesting. What do you mean by that?

Adriana: Plurality is also a category that I borrow from Hannah Arendt who says that the human condition[7] is a paradoxical condition of unique beings. Plurality is therefore a combination of uniqueness's (many multiple uniqueness's). Plurality, however, can disappear within a multitude of individuals when it is not longer possible to perceive their uniqueness because it has been disguised or put aside.

In common debates and political practices plurality is often confused with pluralism: to give or pay attention to diverse positions which normally refer to diverse identities including cultural, religious, sexual identities. Pluralism is not a bad thing but it does not focus on uniqueness,

it focuses rather on cultural traditions or sexual practices. Therefore it deals already with a collective identity which has the tendency to ignore or even to eliminate uniqueness. So there is not a plurality in pluralism. In a certain way pluralism is the opposite concept of plurality. It is very interesting because Hannah Arendt says that plurality is politics because it is always in action. When I truly act in the same place and space, when I can communicate to you my uniqueness while you communicate yours to me; that is politics. This can be seen as a very odd and bizarre idea of politics and certainly does not correspond to the traditional meaning of politics. Hannah Arendt says that the traditional meaning of politics is the one that corresponds to a system of domination, a government system which has to address the problem of governing different classes, territories, contexts. She argues that this is not the authentic meaning of politics. Its authentic meaning is to act together, putting at risk (endangering) our own uniqueness (*è agire insieme rischiando ciascuno la propria unicità*). This is according to Arendt the true democracy, a democracy in action, not a representative democracy.

Lucia: So what does voice have to do with all this?

Adriana: By being based on direct speech (as Arendt suggests), politics is the reciprocal performance of doing and saying. Vocal expression has in this kind of theatre a really important role because it expresses the uniqueness and it also contains what in ancient Greek was called *lexis*, the tonality, the way the voice is set up, the rhetoric of communication...

Lucia: The political space that you have suggested in your book, if I have understood it correctly, is what you have called the *absolute local*. Is this where the political takes place?

Adriana: Yes, because Hannah Arendt says that interaction generates political space, therefore there is a spatial quality of the political. This spatial feature or quality is a space in action, a present space. When we don't act together, when there is no interaction, the Athens' agora becomes an empty space which does not have a political quality. In this sense I argue that politics is always an absolute local, and is spatiality in action. Therefore the absolute local of the political, means to act directly, one in front of the other on a horizontal level. This is from my point of view a way to begin rethinking politics in our contemporary context, or what has been called by many a "post-statual" form. Although the idea of a modern state bound to a territory is still present, we are assisting in the decline of this system of domination which was born in 1600. Contrary to all the opinions of those who have emphasized the local as simply meaning local ethnic culture, to re-think the political means therefore to think in terms of an absolute local.

Lucia: How can we re-configure the issue of freedom of speech according to the absolute local? Freedom of speech is one of the most important elements of democracy...

Adriana: In a very concrete and almost material manner. There is a real freedom of speech only when words can be freely expressed but also when I can talk to you in front of you and you can hear my voice, namely I don't have to designate anybody else to talk on my behalf. We should not look at freedom of speech in a purely semantic way, it is not purely about what I say, and what it is forbidden to say, what I am allowed to say, what is convenient to say. I suggest that we need to pay attention to the vocal element of voice, because freedom of speech also includes the element of direct speech, the words pronounced by me listened by you and vice-versa. In Italian we normally say *prendere la parola* (literally it means "to take the speech", but in English

it is equivalent to "to take the floor"), which in my view means speaking. If we think about the English expression *to give voice to the oppressed*, we could also take this as a metaphor, but this would be stupid. According to my thesis, to give voice to the oppressed means to listen to their voices, to its material expressions and also to give voice to each single person who speaks for himself/herself and not through a spokesperson. I understand that it is certainly difficult to inhabit this radical position but it is important to start re-thinking certain slogans such as *freedom of speech* or *democracy* from a radical point of view.

Lucia: What do you think about the role of listening (to the voices) as part of the democratic process? Everybody can express their opinions but even if we imagine a situation in which the nation state no longer exists, we would have, I suppose, another constituency, which would face the issue of how and where to listen to citizens. How do you see listening as a part of this?

Adriana: The way I understand freedom of speech is in terms of speech practices and not as a principle. I would like to stress the importance of theatricality, of the real performance here. By speech practice I mean a space that is produced by it, a space which is opened or closed by speaking to each other. In this space, listening is not more important than speaking because there is no priority of listening over vocalizing and speaking. We are both spectators and actors. I understand that this is quite a radical position but this is an attempt to re-visit certain old issues from a radical angle. But where are these spaces? The spaces are where they are already taking place or where they have been generated. The role of a certain political organisation or certain management of power (as for example the modern state and its governments) is therefore to facilitate the opening of these spaces where the political

and the freedom of speech is really happening...

Lucia: Can you give me some examples?

Adriana: Historically Europe and the West is a history of many places where speech has been practiced. The history of feminism and the *autocoscienza* (consciousness-raising) groups are for example places of speech practice. The problem is that the system of power has the tendency to close down these spaces including this kind of theatricality and performance that I was describing earlier. The more despotic a government, the more these spaces are normally shut down.

Lucia: It is interesting to hear how Adriana Cavarero and Nick Couldry think about voice and how it relates to listening practices and the political.

Claudia: Nick Couldry mentioned the work of Susan Bickford as one of the few texts that actually deal with listening within political theory. In *The Dissonance of Democracy: listening, conflict and citizenship*, she argues that the practice of listening in political interaction has been neglected by democratic theorists focussing instead on "shared speech as a practice of citizenship"[8]. Too little thought has focused on the practice of listening in political interaction. Bickford suggests that democratic politics requires a particular quality of attention. Like Cavarero, she draws on feminist theory as well as Aristotle and Arendt. From this basis she develops a conception of citizen interaction that takes place within a context of inequality. For her, the space of politics is always a conflictual and contentious one even within democratic societies. Both Bickford and Couldry discuss listening in regard to the idea of *citizenship* relating directly to the state and the politics defined by it.

Lucia: Cavarero's notion of politics is quite different, less to do with representative democracy and much more with acting together, speaking together…

Claudia: Yes, and this chimes with many social movements who have turned away from purely statist politics seeing it as too narrowly defined or too influenced by large corporations. Personally, I think there is some value in thinking of the two positions together, both as politics defined by our relation to the state and the possibility of creating more directly democratic spaces.

Lucia: How and on what terms does Bickford mobilise contemporary feminist theory? Does she refer to identity/ gender politics?

Claudia: Bickford looks to the feminist theorising of inequality to look at who gets paid attention to, "through the haze of socio-economic inequality"[9]. There are ways of speaking: through structure, grammar, logic; voice quality, pitch and accent; affective disposition and the framing of an utterance that affects how others regard us and whether we are heard or not. She suggests that others' perceptions of us affect how we can be present in the political realm. There are norms that govern communication and these are not neutral.

Lucia: How does she theorise listening in this?

Claudia: As very much a deliberative process, as active and creative, and grounded in particular social and political contexts. Listening, Bickford argues is often invoked as a sympathetic orientation that provides an alternative to the dominant quality of the *gaze* and against the despotic quality of speech. Much of this comes from a feminist critique of the gaze. Seeing is seen as free from responsiveness and

engagement, as something that objectifies and disciplines. It is also very much associated with Foucault and the disciplinary technology of surveillance. However, listening can of course also be associated with surveillance through bugging and eavesdropping. Bickford argues that listening should not be contrasted too sharply with seeing as they often work together through for example body language or sign language. Rather, speaking and listening should be characterised by mutual sensitivity, that it is bodily as well as interpretive. And while hearing is always the hearing of an action, listening is a movement towards another's activity[10]. A key point Bickford makes is that this movement towards another should be without absenting the self. Making sure the self stays present while listening to the other is crucial in order to keep the relationship one of peers, a joint action.

Lucia: This idea seems very much connected to feminist practices of consciousness-raising. It is interesting to think how Italian feminists used the term *autocoscienza* which literally means self-consciousness or consciousness of the self, suggesting something of an auto-induced, self-determined process of achieving consciousness. The term was coined by Carla Lonzi who organized one of the first Italian groups to adopt the practice which was originally initiated by North American feminism towards the end of the 1960s. In a book edited by The Milan Women's Bookstore Collective, C-R groups were: "groups of women who met to talk about themselves, or about anything else, as long as it was based in their own personal experience"[11].

Claudia: Yes, we can certainly see how Bickford's perspective relates to and comes out of C-R practices and the theories that followed it.

Lucia: As Cavarero has pointed out, Italian feminism em-

phasised the importance of starting from the self in a relational context with other women. It has been less engaged with academic debates on language and more focused on the political practice of consciousness raising. Cavarero thinks that narration and not philosophical discourse has been the core of Italian feminist practice[12].

Claudia: As far as I can see, this was the case with all feminist C-R practice. But I think there is also something to say here about the C-R groups in relation to knowledge. One of the important points about the groups was that they were a reaction against an idea of knowledge as only being produced through a dominant canon of written books and theories. The shift of C-R groups from reading groups to speaking and listening practices partly came from the idea that knowledge could and should come from women's individual experience in order to adequately challenge dominant forms of knowledge. These narrated experiences were used as a basis for analysis and political action. They created knowledge.

This also had a big effect in academia in unsettling the large overarching meta-narratives that were dominant at the time. Since then of course there has been much debate particularly within academia about the issue of using experience to produce knowledge. The "problem of experience" has been key to humanist/post-humanist debates, raising questions around understandings of the self and subjectivity, what constitutes the political subject and how power operates.

Perhaps it is worth pointing out here that both Couldry and Cavarero take as their starting point an embodied self for which the interior exterior/dichotomy between self and world is a false one. Experience is not essentially private and interior but is situated, intersubjective and social. The subject is constituted *through* experience rather than by it. Experience in this sense can also be thought of as

constructed in relation to historical processes and discourses rather than being truly *authentic* or boundaried.

Lucia: What do you mean by authentic or boundaried?

Claudia: It is the idea that we have an internal truth that is separated by the external, from society, culture, history, this is what I mean by boundaried. To see somebody's experience as really authentic is problematic because we are constructed by the specific historical moment we are in, our subjectivity has much to do with cultural history rather than something which is true in some kind of essential way. We are products of the moment we are in, our subjectivity is the product of a historical moment. What is interesting is what uniqueness means in relation to that.

Lucia: This could be a long conversation because the issue of authenticity was very important for feminism. Carla Lonzi was completely obsessed with the word *authenticity*. In her diary which she wrote as a result of practising *autocoscienza* in the late 60s with different groups of women, she talks about the search for the authentic self. The thesis that personal experience and therefore the words that express it has intrinsic authenticity was an important part of *autocoscienza* (consciousness-raising). As the Milan Women's Bookstore Collective put it: "that authenticity is thought to be absolute in the sense that there is no possible authenticity for women except in what they experience themselves"[13].

Claudia: Yes, at that time this was the issue that was talked about. Since then it has become more problematic to talk about the authentic self.

Lucia: The practice of *autocoscienza* (consciousness-raising) was supported by a perfect reciprocal identification

between women: I am you, you are me. The limits of affirming women's common identity through this reciprocal identification was of course the limit to show differences between women. This is why Cavarero's vocal ontology of uniqueness is very interesting because it seems a move forward from these politics grounded on the idea of the authentic self. To shift from authenticity to uniqueness means to open up a wider political space, which is not solely about gender and identity politics (pluralism) but is also about the recognition of the singular, unique voice of an individual within any plural or collective entity (plurality). Plurality as an assemblage of singularities.

Chapter 4: Collective Listening or Listening and Collectivity

Listening can be understood as an inherent part of dialogue and conversation. But how exactly might it play a role in constituting a group? Ultra-red has already described listening as a collectively organised process, members of PWB have spoken about how listening to testimonies brought the group together and with feminist C-R, their listening practices were predicated on a reciprocal relationship with speaking. Listening might help to create some kind of collective that could be momentary and fleeting or something more lasting, but what are the implications for each of these forms? This chapter is a further exploration of the relationship between listening and collectivity, looking at different modes of listening collectively and their relationships to politics. Questions are raised such as whether listening is always active or whether there are passive kinds of listening. What relation does listening as an act have with agency? Can listening produce agency and if so how and for whom? The question of action also raises further questions. What constitutes political action can itself be difficult to pin down, especially in relation to artistic practice and contemporary modes of work that have incorporated intellectual, creative and cooperative aspects. In this respect listening and participation are also explored. Hannah Arendt's categories of Work, Action, Thought and Speech are interrogated and listening is also discussed in relation to voice and sound and how this might connect with new ways of thinking about action and collectivity. Adriana Cavarero has already envisaged the possibility of a collective entity or plurality that stresses the importance of recognising singularity and uniqueness in relation to individual voices. But what does this mean for thinking about collective political action? Are there ways of forming collectives other than through some kind of unification or

homogenisation? How might this change our relationship with ourselves as well as with others? What are the points of tension? How do issues of voice change when related to collective practices? We begin by unravelling some of the issues surrounding how we think about collectivity.

The constructed conversation in this chapter includes voices from those that have been most involved in contemporary collective work: members of the Precarious Workers Brigade, Janna Graham and Robert Sember from Ultra-red, and Ayreen Anastas and Rene Gabri.

Lucia: For me all of this started by looking back at the literature produced in the field of sonic studies, reading in more depth the work of Cavarero and trying to connect those theories and practices of voice and listening to what I was experiencing during Occupy London. The two of us started to work together from that moment, asking our initial interlocutors to provide some definition of "collective listening" but this proved very difficult.

Claudia: Perhaps we can try to explore some of those difficulties here.

Lucia: If we look at the etymology of the term *collective*, it derives from Latin *colligere*: to gather together, from *com* (together) and *legere* (to gather). Collective listening might therefore be defined in terms of an auditory collective experience, the space and time of getting together through the act of listening. As Brandon LaBelle put it in his book on sound art, listening is "a form of participation in the sharing of a sound event"[1].

Of course, a sound event can be many things, a concert, a music party, a noisy protest, or a car crash. It depends from which angle you want to look at it. Although this definition serves the purpose of introducing the relational aspects of sound art and its engagement with time

and space (something that we won't investigate here), taken as a general statement it also allows us to speculate further about sound as a relational phenomenon. Perhaps, what LaBelle is not saying clearly in this book (but he does explore it in other writings such as *Acoustic Territories*) is what kind of forms of participation sound and listening produce within different specific contexts. This is some-- thing that seems little discussed in the field of sonic arts, at least compared to the huge critical debate on participation that has occurred in the visual arts[2].

Claudia: This question of the different kinds of participa- tion listening might produce in different contexts seems very important. I'm thinking about what Anna Sherbany said when we asked her about listening in the context of C-R groups. The term *collective listening* could have con- notations of the passive listening that Anna was talking about. From a feminist perspective, listening has often been denigrated as a more passive "feminine" attribute, but it could be argued that there is a substantial difference between hearing and listening. While hearing is passive – we cannot close our ears – listening is a conscious act and therefore in some sense active. I think what can easily have passive connotations, particularly in thinking about this phrase "the sharing of a sound event" is through the idea of an audience.

Lucia: Well, the experience of listening together at a con- cert, or to a religious or political speech could be described as a form of passive listening. However, there are modes of listening in relation to contemporary music and sound art which try to overturn the traditional relationship be- tween musician and audience. From the early experimen- tation of John Cage to the spatial manifestation of sound art, from the Soundscape project by R. Murray Schafer to the renewed interest in field recordings, listening to sound

has been explored not only as a tool for composition but more and more as a participatory practice that involves the active role of the listener. For instance artist Steve Roden describes his sound installations in terms of active listening, as a way to activate both the listener's perception of space as well as the acoustics of the space itself[3]. It could be argued that these new forms of listening are intrinsically political as they represent a breakthrough in the history of music but also in terms of auditory perception[4]. However, we are not interested in dealing with listening as the moment of the listener or spectator, nor as the exclusive moment of the subject.

Claudia: So, how then could listening become active in the context of or even as a catalyst for some kind of coming together?

Lucia: One reference that comes to my mind about listening and collectivity is Adorno's reflections on *Composing for Films*. In this essay he argued that the phenomenon of listening is intrinsically related to collectivity because it produces a sense of togetherness. He wrote: "acoustic perception preserves comparably more traits of long bygone, pre-individualistic collectivities than optical perception… [because] ordinary listening, as compared to seeing, is 'archaic'[…] it has not kept pace with technological progress […] the ear, which is fundamentally a passive organ in contrast with the swift, actively selective eye, is in a sense not in keeping with the present advanced industrial age and its cultural anthropology… This direct relationship to a collectivity, intrinsic in the phenomenon itself, is probably connected with the sensations of spatial depth, inclusiveness, and absorption of individuality, which are common to all music"[5].

Claudia: That's very interesting – this idea that listening is almost primitive.

Lucia: The idea that music conveys collective sentiments and animates a kind of communitarian desire, is one way to think about listening as an auditory collective experience, as a mode of collective sharing. From national anthems, to partisans' songs, from rock concerts to rave culture, the history of (western) modern listening is often a twofold story of collective identity. If on the one hand it has encouraged individual freedom, on the other it has served nationalist ideologies.

Claudia: Some people might find this aspect worrying because this archaic sense of collectivity can be harnessed towards creating nationalist or fascist affects or a collectivity that manifests as a homogenous mass. It can be a very powerful thing, being filled with affect generated by an anthem. I'm not sure that this just applies to music. Ideas of listening together might also conjure up images of an audience listening to a political orator, and that, at its most extreme form, might also harness a collective affect that while producing some kind of collective form of agency also subsumes the individual to create an *unthinking mass*. This seems to be part of the problem in thinking about collectivity.

Lucia: What interests me is how this sense of togetherness produced by acoustic perception can serve opposite demands, being an empowering experience on the one hand but also disempowering on the other. It seems quite hard to draw a straight line here... And also about the different levels of perception and how this is somehow controlled or organised by certain power structures.

My question is how it might be possible to reinvigorate a sense of collectivity through listening as a positive and empowering challenge for society. Maybe this is just another utopian project or a romantic desire of togetherness!

Claudia: Perhaps. We do live in a fragmented and indi-vidualised society. But is a sense of togetherness enough? I think we're looking for the connection to politics here and how we might connect collective listening historically with the loss of a collective political subject.

Lucia: We already saw a very different model with C-R. Lis-tening does not have to just mean listening to an a priori, acontextual sound event but it can also establish the terrain for a dialogue between different subjects.

Claudia: As Anna Sherbany said, it is the speaking as much as the listening that counts.

Lucia: I am interested in how this relates to voice. Our examples are related more to dialogic practices such as C-R rather than to sonic arts and their spatial and envi-ronmental concerns.

Claudia: In our examples we are mostly dealing with lis-tening to voice in a more reciprocal model than that of an audience. This is a very different kind of collective listening and a different kind of participation.

But is listening to voice always necessarily about attending to sound? Nick Couldry argues that it has much more to do with paying attention and registering people's act of giving an account of themselves in whatever way that may be. He made the example of deaf people.

Lucia: Nick Couldry speaks about voice in terms of meta-phor and not sound. I would like to argue that voice can be understood not only in a metaphorical sense, but both as metaphor and sound. In the case of deaf people the sound of the voice can be perceived as utterance without articula-tion (as an object voice, as we could say in Dolar's terms[6]. Utterance is very much a process of an embodied voice: it

is air that vibrates through the body and is emitted from the body. What sign language provides in this case is a tool for the articulation/vocalisation of speech which otherwise would be hard to understand and decode, but which nevertheless can be linked, in principle, to sound phenomena. John Cage's reflections on silence might also be useful here. He demonstrated simply through his notorious episode in the anechoic chamber that silence does not exist: he could now hear sounds that are normally inaudible, like the sound of his blood flowing through his body. Where there is life, there is always sound.

Claudia: Of course voice can be understood both literally and metaphorically. But what does it mean politically to place an emphasis on the sonic aspect of the voice? I'm curious to know what is at stake here for you in insisting on sound.

Lucia: Well I share Cavarero's thesis of rethinking politics through voice and uniqueness, a politics which gives prominence to vocality, a principle that also pertains to the category of life! Although I love sound recordings, and I make them as part of my own curatorial practice, I am a bit suspicious of the extreme fascination and fetishisation of the disembodied voice that seems to reign over sound artists. I certainly believe in the power of recording technology and radio as a very effective media of communication, and I myself have perhaps probably contributed unwittingly to the aesthetisation of voice as a technological trope. But when we come to look and talk about political art and activism, I also believe that embodiment is a necessary condition for politics because it implies the very real possibility to act in the flesh. There was a collective of activists quite recently called the *nanopolitics group*. Their aim was to rethink politics through the body. Careful (or attentive) listening was one of the key exercises in their political practice.[7]

Rather than inscribing listening to the terrrain of sound art and music, the question in regard to the intersection of art and activism is the role of listening in dialogic practices and group formation. This also takes into account a shift from the politics of voice to the politics of listening.

Claudia: With the consciousness-raising groups, the forming of the group was obviously part and parcel of the listening and speaking process. One of the most powerful things about the C-R groups was that the speaking and listening that took place in them was a collective process. Women found that by speaking about their own private or domestic lives and sharing these experiences they realised they were part of a social phenomenon. That women felt bad and did not understand why, and the consciousness-raising groups were places where they realised that these were not unique and individualised situations[8]. The reciprocal nature of the speaking and listening within the groups created a feeling of solidarity which not only enabled women to go back into their domestic lives and change things but also to move the struggle into the broader public domain with campaigns and other kinds of political action. One woman, recorded for the *Sisterhood and After Oral History Project*[9], said that the groups were what made up the women's movement: if you weren't in a consciousness-raising group at the time you weren't really in the movement.

Lucia: There are similarities here with the Precarious Workers Brigade in terms of the sharing of testimonies and stories. With PWB for example, the organization of various meetings and workshops focused on listening to different stories about precarity and free labour, and this represented a starting point for becoming a group. In particular I can think of the tribunal at the ICA – which was a kind of platform for giving and listening to many testimonies – and became a catalytic moment for whoever at that particular mo-

ment wanted to address the issue of precarity collectively.

Claudia: I think the whole issue of precarity also deals with feelings of individual inadequacy that when shared become clear that they are also part of a social phenomenon. In this sense, there are definite parallels with feminist consciousness-raising, although PWB has never been solely a consciousness-raising group. If we think about this in terms of how neoliberalism emphasises the individual's relationship to the market and how this works to privatise and individualise risk, the sharing of individual stories in order to see the wider social picture could be very useful.

Lucia: PWB has been operating between a group and a network. Its members are not always necessarily the same, it is a quite fluid group: people can come and go. However it does have an ethics code that somehow helps the members to orient and define their work.

Claudia: If we are thinking about different kinds of group formation, Occupy was an even more temporary coming together or formation. The question of its identity was quite puzzling for some people because it seemed so amorphous.

Lucia: What about 16 Beaver in New York, Ayreen and Rene? I am interested in the *Commons Course* that you have been developing…

Rene: Yes, that's really coming out of something that we felt more collectively and it's more something we initiated with others in 16 Beaver after the experiences of Occupy. We are trying to build a more tangible space for listening and thinking together that could also be critical, analytical, speculative, and playful. I think this question of the group is important but I don't know what more I can say though. Perhaps I can say that this is a process that also takes time

because there are people that you feel you have heard for a long time, but only when you do actually hear them there is a certain kind of bond that you never had before. This is somehow the experience of 16 Beaver, having this space for a long time and having certain people coming…

Ayreen: It's more to get beyond one's self for sure but it's not an identity of a group. It is more the practice of being there, thinking together and then seeing where one gets together. It is beyond the group and also more about the friendships, the relations that can result from such activity.

Rene: It's not like some self-same thing: like uttering constantly and then you can just finally hear it. It is a kind of listening and hearing because they have different kinds of signification.

Ayreen: But you need to create the culture for it. For this kind of space or place it takes time because the culture, of let's say the general art context in New York, does not have necessarily this way of being together, of meeting together without it being certain openings or a specific panel or a conference. So you need a continuous engagement in order to create such a space for oneself and others.

Lucia: For Ultra-red listening is also part of a whole pedagogical process. Robert and Janna, you were talking about the need to use certain protocols of listening in order to deconstruct or analyse a group situation. Listening and not just speaking seems in this sense a very important element in group formation.

Robert (UR): I agree. Which is why I begin to ask the question "what did you hear?" It sounds like a very simple question. That pronoun *you* – who is asking the question, who is the *you*, right? As we go through these listening pro-

cedures there comes this point where it's very clear that what you're starting to listen to, is how you listen. I can tell a little bit of a story about this. Recently I went to South-ern Ohio, where I taught. The place is known as Appala-chia and is a part of the US that is associated with poverty. It's on the border of what used to be slave states and free states and this intersection between very poor whites who are often the descendants of immigrants who came from Europe who were also impoverished. They immigrated to the US because they had heard that an immigrant could get land. So they arrived with these deep multi-genera-tional histories of poverty. They got to this area and got land but this didn't really alleviate their poverty as they were immediately in this nexus of slavery. Appalachia is a very complicated, extraordinary and critical space, because the wisdom and knowledge that lies in that space about power is profound. So I went back there recently and did some very basic listening sessions which began with the question: what is the sound of Appalachia? I worked with small groups of residents of these towns that had decided to form their own little historical societies just to remember the spaces they have been living in. Part of the history of this place is about the old mining towns. The mines had moved on, there is no economy to sustain them any longer, apart from relentless grabbing at what government hand-outs may come their way. It's incredibly difficult. In a cer-tain sense one of the only things that is left there is a kind of a memory. There are all of these movements that are try-ing to figure out how to deal with this, and one possibility is to translate memory into commerce through museums that generate cultural tourism. So the big question is what history is going to be told. Suddenly this idea of gathering together and asking what the sound of Appalachia is starts to explode into questions about what is our/their value: what do we know, how can we commodify ourselves, and these sort of things. One thing that they do have is a deep

knowledge of where the United Mineworkers was formed. The union was set in those mines, around those towns and became the foundation to the labour movement of the 20th century. It's militant and extraordinary and the knowledge that lives in those hills about the formation of that movement is really incredible. But there is this conflict of whether one has to dampen that knowledge in order to produce a kind of nostalgia, which is poverty nostalgia in a certain sense. We sat and went through this very simple process of listening, and people were writing down on pieces of paper what they were hearing. They knew each other very well, they have worked together for a long time and they started to arrive at the point of their own contradictions. This happens, when you start to listen with a historical consciousness, with this other object form of listening, which is just to describe the sound you hear. They started realising immediately that they were beginning to slip into some kind of nostalgia. They started hearing the conflict in their own mode of listening. Their collectivity was therefore grounded in a crucial and critical struggle of how they were valuing or not valuing themselves. Where our conversation concluded was: what does it mean to always look outside of your own space for a kind of validation? Does the group have the capacity to validate itself, or does it always need to circulate in order to be able to produce a kind of value? This was a very simplistic moment of the sort of origination of the group and the question of autonomy became really important.

What we can learn from this is that there is something important in the constitution of the collective through arriving at that point of listening to yourself. I think it's really helpful when you begin to hear your own contradictions and decide then to actually ground yourself in the investigation of them. For me, just witnessing a basic listening procedure and arriving at that point, was a real reminder of the value of the process. When I'm organising

these things and I am giving the instructions I often hear this voice at the back of my head that says: "This is such bullshit". Why am I asking people to do such a silly thing? Then I hear Leonardo [Vilchis] saying: "Trust the process!" [Laughter!] So I have these two voices and part of my own conflict, which is an egocentric notion, is to have something to give you that is of value and that you don't already have.

Lucia: The process that you have described is like going back to a basic grammar that is almost forgotten because the question "what do you hear?" seems no longer rooted in our culture. A common question would be instead "what do you see?" If we were able to listen to our own contradictions more often we probably wouldn't need psychoanalysis. [Laughter!] It would be rather a matter of common experience…

Claudia: It also sounds like listening plays a role within the collective itself, to constitute the collective, as well as with the groups you are working with.

Janna (UR): Yes, sharing the protocols and the processes of our listening sessions is a very strong component of our work… We send dispatches after we've completed a project, we talk to each other about what happened, we talk about how different kinds of protocols for listening change dynamics within groups and political processes. What is produced by those protocols? But also, how they are resisted and why? How they are reshaped by those who engage with them? How they are conformed to, and the conflicts that arise from them? We also reflect on what it is to cross between art and activist/organising contexts, the way in which listening sessions resonate in those two different kinds of spaces in completely different ways, and how they produce very, very different effects.

Robert (UR): Collectivity organises itself around contradiction, as opposed to unification.

Janna (UR): And isn't just about celebrating diversity or equality, in a kind of utopian sense that doesn't actually address the conditions.

Robert (UR): This is why Arendt is essential.

Lucia: And this is why Cavarero's reading of Arendt's category of uniqueness in terms of vocal expression or *vocality* seems crucial to rethink the relationship between logos and politics. What is interesting for me is how voice brings together all these connections between psychoanalysis, the sonic self and the political. To re-insert politics within the realm of phenomenology we have to go back to voice, because through voice we return to the human dimension of sound, to the fact that we recognise the uniqueness of each human being.

Robert (UR): I'm curious about this, it's a kind of reclaiming of humanism. It needed to be deconstructed because it had justified such brutality and violence. It was in crisis. In some instances that I'm aware of, in anti-racism struggles, humanism never disappeared. This is amongst black intellectuals and often feminist intellectuals that we maintain this focus on the question of what it means to be human, whereas in Europe there had been this crisis of humanism.

Claudia: This point about collectivity being organised around contradiction as opposed to unification is an interesting one because it raises many questions about identity and recognition within groups. Individuals might feel inside or outside a group. This is the politics of group membership in which there might be a kind of shared sameness with some, and therefore a feeling of difference from others.

The extent to this sameness and difference perhaps depends on how rigid or fluid the boundaries of the group are[10]. If group identity becomes too rigid, it becomes a homogenising force: the identity of the group "we" becoming more important than everything else. But even within a group, individuals can feel more inside or more outside, more the same or more different. This is why recognising the contradictions and contingencies of collectivity is important.

Lucia: But normally those contradictions and contingencies are not recognised as part of political activity, we rather have political groups (parties) that often antagonise each other's position and re-organise themselves around those oppositions for the sake of (re-)establishing their own power instead of representing diverse voices within the same group.

Claudia: You're talking about political parties that are connected to state politics. It's always newsworthy when there are obvious divisions within a party. In terms of forms of collectivities, a more homogenous "we" has been associated with a notion of politics focused more around the state[11]. Political activity which takes the state as its object is underpinned by an idea of experience as universal. Universal experience privileges political strategies which address the institution of the state as the way to do politics. Collectivities could be seen to fail at the point at which they start to produce a homogenous "people".

Lucia: Which can lead to forms of totalitarianism...

Claudia: Or at the very least, of some people not being recognised as belonging to "the people". Feminist C-R groups precisely challenged this view of both politics as state orientated and experience as universal. Their emphasis on analysis based on personal experience from multiple perspectives was used to directly challenge universal scientific

and academic narratives. This (as I mentioned in Chapter 2: *Towards a Politics of Voices*), then leads to academic debates regarding the value of experience with critics arguing that this model was based on ideas of an authentic interior self that were themselves based around Cartesian interior/exterior, mind/body splits. We can begin to resolve this if we start to think about experience as both situated culturally and historically and as embodied.

Lucia: It seems to me that Cavarero uses embodiment to resolve the Cartesian mind body split.

Claudia: There are also other thinkers that have been re-thinking collectivity for example in ideas of the multitude, but the main point is that if we can think or rethink collectivity as an assemblage of singularities rather than subjects or individuals or a homogenous mass, we can not only go beyond some of these issues but also explore collectivity as a way to interrupt neoliberalism as an individualising force by being a source of difference and transformation. However, that's not to say that collectivity or co-operation do not exist within neoliberal modes of production.

Lucia: Cavarero develops her thought on embodiment thorough feminist theory and connects this to Arendt's notion of uniqueness. I think we need to go back to Arendt's idea of plurality: "Human plurality is the paradoxical plurality of unique beings" she wrote in *Action*[12]. This idea of plurality inspired both Cavarero's politics of voices but also Jean-Luc Nancy's, notion of singular-plural. According to Nancy "there is a singularity only where singularity ties itself up with other singularities". From here the idea that a community or "being-in-common means that singular beings are, are presented, appear, only insofar as they appear together (*cum*), are exposed, presented and offered to one another […]."[13]

It might seem contradictory to think about togeth-erness as plurality, but in Arendt's terms, human plural-ity is "the basic conditions of both action and speech", in simple words, the basic condition of politics. She argued that the "revelatory quality of speech and action comes to the fore where people are with others and neither for nor against them, that is, in sheer human togetherness [...] Whenever togetherness is lost, that is when people are only for or against other people, as for instance in mod-ern warfare [...] [in this case] speech becomes indeed 'mere talk'[...] simply one more means towards the end [...]."[14]

Following on from this point we could say that the conditions of being collective (collectivity), or the quality of being together pertains to speech and it is entangled with voice politics.

Claudia: So for Arendt politics is speaking and acting to-gether...

Lucia: Exactly. The other thing though that is important to me about Arendt's thought around plurality, is that it allows us to think about collectivity as an open and shifting process in time and space, rather than a fixed entity (and identity) tied up to notions of class, gender, religion, language etc.

Claudia: There are other schools of thought like the Au-tonomist Marxist tradition (Italian Autonomia) which also sees collectivity as about process. Class for example is seen as a compositional process, shifting and changing rather than being a fixed identity. Their compositional method is influenced by Deleuze and Guattari's notion of collectivity as a decentred site of multiplicity, and their emphasis on processes and changing states, the "machinic".

Lucia: Yes, but what about the idea that voice is always relational and as such introduces the Other? "Listening

to the voice inaugurates the relation to the Other"[15]. Arendt acutely observed that human distinctness is not the same of otherness, or *alteritas* as in medieval philosophy. When referring to human beings, the notions of *otherness* and *distinctness* become *uniqueness*. So all human beings are unique, and what characterises their embodied uniqueness (as Cavarero has further developed from Arendt) is their singular, unique voices. Only when and while human beings interact through speech and action, can they communicate to one another this uniqueness. "Without such communication, without action in a shared space of reciprocal exhibition, uniqueness remains a mere ontological given – the given of an ontology that is not able to make itself political"[16]. This means, in simple words, that without this reciprocal act of speaking and without this reciprocal act of showing what makes us (appearing) unique, uniqueness is insufficient to create a political space.

Claudia: I think it is important to talk about the limitations of Hannah Arendt's thought as well. Her categories might be limiting if we think about the contemporary context.

Lucia: In what way?

Claudia: Arendt's categories are based on traditional philosophical ideas from Aristotle about what counts as work, labour, thought and action. These categories are kept very separate, with thought for example being relegated to the private sphere – it cannot count as action or be collective and plural.

As labour has become more immaterial in the contemporary post-Fordist context, it becomes as much about creating ideas and concepts as things. Immaterial labour is also sometimes termed cognitive labour or intellectual labour. In this situation, knowledge production becomes a category of labour. I'm thinking Arendt through Paulo

Virno here. In fact, for Virno, in a context in which "precarisation" has taken place, an alliance between Intellect and Action is very necessary in order to counter the joining up of Intellect and Work that has been taking place. It therefore becomes necessary to think together as well as just to speak and act together.

Lucia: What do you mean by alliance between Intellect and Action? What does Virno mean exactly by *Intellect*?

Claudia: Just that thinking and political action need to come together. Virno follows Arendt's categories, but the category of Thought becomes Intellect. This is to look to Marx's concept of the *general intellect*, in which thought, knowledge or the power of the mind, becomes public in some kind of way, erupting as Virno puts it, in reference to Arendt, into the realm of appearances, so not as separate or private in the same way as Arendt originally perceived it. Virno agrees with Arendt on the relevance of thought, speech and action in relation to politics but not in their configuration. The changing nature of work means that now much contemporary labour is intellectual and creative. The economy increasingly relies on intellectual and creative capabilities. Not only that but it is often collective and/or cooperative. For Virno, the space of cooperation that Arendt describes, is very much incorporated into post-Fordist labour conditions. But this doesn't mean that it gets completely dis-abled. The incorporation of the intellect into production means that it, in itself, becomes productive. The intellect is put to work and it is precisely this productivity that also produces the potential to become productive for politics.

Lucia: I think Arendt talks in terms of inter-action rather than cooperation, and by using the term inter-action she stresses the reciprocal nature of acting together. Coopera-

tion is of course a similar term, as it both means working and acting together for a common purpose. If I have understood well Virno's reasoning, these categories acquire another connotation in post-Fordism: what was thought as an almost exclusive potential political action for Arendt (sharing and exposing each other's singularity to one another) has become, in the age of cognitive capitalism, a working condition *per se*.

Claudia: Yes, and while under Fordist conditions it was very possible to separate spheres of activity (such as work, thought and political action) Virno argues that in the contemporary moment, work in fact often comes close to resembling political praxis particularly if it emphasises social relations and does not produce an object. This both makes it more difficult to define what political action is, while at the same time, increasing the possibilities for political action within the realm of work and the intellect. The contemporary organisation of labour blurs the boundaries between work and life. It is very pervasive and hugely uncertain...

Lucia: This make me think about what Florian Schneider wrote in his essay *Collaboration: The Dark site of the Multitude*:

"The nettings of voluntariness, enthusiasm, creativity, immense pressure, ever increasing self-doubt and desperation are temporary, fluid and appear in multiple forms, but refer to a permanent state of insecurity and precariousness that becomes the blue print for widespread forms of occupation and employment within the rest of the society. It reveals the other face of immaterial labor that is hidden behind the rhetoric of cooperation, networking, and clustering."[17]

So the typical condition of the contemporary worker in post-Fordist production, the "affect industries" as well as networking environments in general, is a scenario in which

collaboration (working together with others, especially in an intellectual endeavor) actually means to increase the level of flexibility of the worker who consequently feels constantly under pressure, exposed and anxious. In a word, precarious.

Claudia: Yes, and it is this precarity that while creating anxiety and instability for many, also enables new alliances and connections to be made. That's how Virno theorises the multitude, although (different to Hardt and Negri's formulations of it) it is important to point out that it is not guaranteed.

Lucia: OK, well this is very important to take on board especially if we are thinking about precarity in relation to cultural and intellectual labour. Thinking together has to be seen as having the possibility of being counted towards political action. And we can of course connect this to the work of PWB as a group that deals with some of these issues of precarious work. The group is organised around the idea of producing research together, of thinking and acting together.

In terms of the genealogy of the Precarious Workers Brigade, I think it's important here to mention the Micropolitics Research Group. It came about very much through using collective research as a form of action. Sharing some of the same members of the Micropolitics Research Group, a new group – the Carrot Workers Collective – also formed. This collective started a series of enquiries about free labour in the cultural sector. The Precarious Workers Brigade originated from the affiliation of members of these two collectives plus an influx of new people through the tribunal at the ICA.

The Micropolitics Research Group began (in London) originally as a reading/discussion group exploring various ideas of micropolitics, transversality and self-

organisation through the work of Félix Guattari, Gilbert Simondon, Suely Rolnik, Brian Holmes and others. They were trying to critically address the managerial turn of contemporary neo-liberal culture and power relations through research as action. The group also focussed on processes of collective forming or becoming. Thinking about their "experiences and ideas regarding collective becomings – both from the psycho-subjective point of view and with regards to the ways in which they organize their group processes (particularly in political and cultural contexts)."[18]

The group organised a series of discussions about militant research which culminated in a workshop with Colectivo Situaciones. In a way the Micropolitics Research Group could be seen as an exploratory phase that then led to the other two groups.

Claudia: Micro-politics can be understood in a number of ways. On one level it is the politics of interpersonal relations as opposed to the politics of states and nations. Feminism for example, endeavoured to define politics as other than that purely defined by the state. With the statement "the personal is political", the everyday (housework, sexuality and personal appearance) became grounds to fight political battles. However this, as we have seen, was not just about demands for change on the level of the individual but also on a societal level, aiming to both empower women to make changes in their individual lives but also to address deficits in equality legislation and other places where the state could change things.

Deleuze and Guattari also developed their own concept of micro-politics in order to try and understand how power operates on a micro level, how the power of a totalitarian state seeps into the details of people's everyday lives, how institutions replicate themselves through interactions. It is not just a question of scale though. A key notion is that when looking at the dynamics of groups of

people, what passes between them, is important as a factor in determining the outcome of the social process as a whole. Guattari's work at Le Bord, and his development of institutional analysis, attempted to address the multiplicity of relations between individuals and groups within institutions all of which, he realised, played a role in both how the institution runs but also in constructing the subjectivities of the individual patients.

Lucia: Both these concepts of micro-politics fed into the Micropolitics Research Group. I think it's interesting that Guattari's institutional analysis was born in France at the same time as feminist consciousness-raising groups. There are at least three points in common we could mention: firstly the critique of disembodied theory (e.g. the critique of a metaphysical, absolute subject that pretends to speak from a neutral place); secondly the development of new forms of (collective) analysis which wards off any hierarchy and as such have been distinguished from any (psycho)analytical practice that gave exclusive responsibility to an "expert" person or a group; and thirdly the development of a political practice based on action and research, sometimes called militant research.

Claudia: The ideas of the 1960s and 70s were of course born in a very different climate.

Lucia: But there has been a contemporary resurgence of some of these concepts (transversality, micro-politics, the personal is political, action-research, co-research) as tools to help to think about the connections between theory and practice, research and action[19].

Claudia: Perhaps because of the growing process of precarization and the need for intellect and political action to come together. Listening to, and sharing stories and testi-

monies about precarity has been for PWB an effective form of militant participatory research and a political action that sometimes crossed over into or used the language of art, for example with their tribunal.

Lucia: The work of Ultra-red can also be linked to militant research, in particular (if we think what has been produced outside Europe) to the theories and experiences inspired by Paulo Freire's *Pedagogy of the Oppressed*[20], which gained an important presence in Latin America (from here the development of Participatory Action-Research). The rhizomatic structure of *AND AND AND*[21] and the collective gatherings of 16 Beaver have also been described by Rene and Ayreen as a space for thinking and listening together. So the ideas of micro-politics and transversality which stand as the basis of these groups can be seen as an attempt to instigate collective processes of knowledge production through research and action.

The other crossover that is worth exploring here is between the political and the therapeutic. Micro-politics (as the research group put it) was as concerned with the psycho-subjective as with questions of political organizing.

Claudia: I'm also very interested in this crossover. I was for many years a member of a peer-counselling organization.

Lucia: Well, different forms of speaking therapy such as counselling and psychoanalysis can be seen as listening based practices. In other words, listening constitutes a pivotal element of these practices, and is, if you like, the very instrument of these kinds of therapies. In distinguishing psychoanalytical listening from religious listening, Roland Barthes highlighted the idea that psychoanalysis inaugurates "an inter-subjective space where 'I am listening' also means 'listening to me'"[22]. He argues that in psychoanalysis there is not a clear separation between speaker and lis-

tener (as for instance, in religious confession) because the "listener's silence will be as active as the locutor's speech: *listening speaks*" he says.[23] How does peer-counselling work?

Claudia: The way that the counselling organization I was in was run, meant that everybody took turns being both counsellor and client. It also put politics, in terms of both identity politics and the idea that social change comes directly from interpersonal relations, at the heart of its philosophy. The organization was very much influenced by feminism and by C-R as a process.

Lucia: As we discussed in the chapter about feminism, the analytical sessions of each C-R meeting were the moments in which women started to make connections about their personal stories and to understand that "personal problems are political problems". Carol Hanish coined the term *political therapy*, to distinguish it from (psycho)therapy.

Coming from a different perspective, Guattari developed what he termed schizo-analysis, placing political activism and psychoanalysis on the same ground. As Deleuze commented in his introduction to Guattari's collection of texts on psychoanalysis and transversality, "a militant political activist and a psychoanalyst just happen to meet in the same person". Subjectivity, he explains, is thought of by Guattari as a group phenomenon: "the individual is also a group"[24].

Claudia: I find it interesting that the term *political therapy* has also more recently been used by autonomist thinker Franco "Bifo" Berardi, (influenced by Deleuze and Guattari and Schizoanalysis in particular), in relation to how immaterial and affective labour has affected the bodies, minds and souls of workers. He states that "in the days to come, politics and therapy will be one and the same"[25].

Lucia: I guess I am more interested in what we might take from feminist political therapy because the issue of precarity seems very much connected to the increased feminisation of labour. For example there is a study by Cristina Morini which shows how cognitive capitalism tends to prioritize extracting value from relational and emotional elements, which are qualitative characteristics historically present in female work.[26]

Claudia: I think it is this idea of reframing things that are thought of as individual issues and seeing them instead as parts of systemic problems that seems really key. I think it's worth saying that although many gender issues that the C-R groups discussed are still relevant, the particular legacy we are tracing is about the voicing and sharing of experiences that depersonalise them and make them visible as social. This is so that rather than accepting the privatisation of stress and distress with the individual taking all of the burden they could be seen within the framework of the changing nature of work and the stresses involved. As we've seen, listening plays a key role in this.

Lucia: This is what the Carrot Workers Collective and PWB have been trying to address through their publications (e.g. the internships counter-guide[27]), workshops, public actions and more importantly through solidarity projects with other groups. In discussing the hopes, fears and desires of precarious workers, PWB's workshops look at how many aspects of precarity are often internalized by the subject as individual problems.

Claudia: PWB has used feminist-consciousness raising strategies when collecting testimonies and this could be seen in some ways as a legacy of the political therapy as described by Hanisch although not directly using the same form. PWB's main focus is on precarity as a contemporary

condition that now includes all kinds of labour that weren't so precarious before. If we think of precarity as a state of being. It is one that shifts antagonisms which were previously located externally, to the psychology of the worker. For example, manging the self and feelings of anxiety around perceptions of success and failure. Therefore, dealing with this internal state is crucial.

Lucia: PWB certainly sees precarity as a psychological condition that needs to be deconstructed and made visible as a social issue.

Claudia: Bifo talks about precarity in terms of the wider mental health issues, while the PWB's emphasis is not so much on mental health *per se.*

Lucia: Their collective investigation created a shared space that empowered precarious individuals to take action as part of a group. It might be worth remembering here that PWB works normally under the collective name and not in the personal names of its members. (In terms of this conversation, members' names have been changed in order to respect the rule of anonymity.)

Claudia: In this regard it will be helpful to hear more from them. Tania, or anybody else from PWB, do you want to comment on this?

Tania (PWB): Within PWB we have been talking about collectivity and political statements that can be produced by the group anonymously, but also about the group producing a safe space to talk about things.

Lola (PWB): I think it is very interesting to think about the idea of singularity of voices not attached to their proper names.

Chloe (PWB): It is interesting what you are saying because there are two things that can relate to my own experience. The first one is the tribunal when my testimony was read out by somebody else. I felt that I was being voiced by someone else, and that the anonymity was super important there. To be part of the collective process, to me personally, made me think that my voice was part of that, voiced through the collective statement or something....

Lola (PWB): But the story that was told (at the tribunal) by another person was your story, right?

Chloe (PWB): Yeah, it was my story.

Lola (PWB): And it's still your story, your voice, but the way in which it was heard was different.

Chloe (PWB): That's right.

Lola (PWB): It's like a channel, isn't it?

Chloe (PWB): Yeah.

Lola (PWB): I like this idea of the collective as a channel.

Chloe (PWB): And we voiced as a collective. We voiced testimonies from ourselves, from people who have come to meetings, but also workers or ex workers who had worked at that institution, and that moment when our members spoke the testimonies of the people who had been working at the ICA, it was an incredibly powerful moment. To hear the voices of these people who had been through difficult working conditions in the space we were in, and knowing that those were not the people who were standing up and speaking, it was really moving.

Martha (PWB): I think that one fascinating but also complex point you are describing is about polyphony, so there is multiplicity of voices and also the voice of PWB.

Lucia: When we were discussing speech politics before with Cavarero and Couldry, we were thinking about a politics in terms of a multiplicity of voices and how this could be envisaged in our future landscape (the shift from speech to voice politics) and what implications this has for listening. In the next chapter we will examine what this means on a macro political level and what happens when we come into contact with institutions.

Chapter 5: Institutional Frameworks

What happens when we come into contact with institutions or try to create new ones? In this chapter those structures and mechanisms of social order and cooperation that govern our lives in various ways are investigated. In talking to our interlocutors about working with and within institutions, issues of access and normative behaviour, ideas about duration and the possibility of opening up other spatial and temporal rhythms and practices emerge. How do normative frameworks function in relation to listening? How might we allow mutual exchange on an institutional level or create institutions that are able to hold voice and listen attentively? When things become rigid, how do we negotiate conflicts that arise? In relation to the practices of some of our interlocutors, these questions are particularly pertinent in relation to institutions involved in gentrification processes and participatory art projects. We start to unpick some of the contradictions around relational art and collective practices supported by art institutions such as galleries, biennials and public art schemes and trace some of the possibilities as well as the limitations within these contexts. Can art spaces be spaces for political action?

Towards the end of the chapter, we turn from institutions as organisations and the buildings that house them to the virtual world of social media and technology. How does this network differ as a framework for listening and participation? How and where might we locate the political and what are the limitations and possibilities here? This question of defining the political runs throughout this chapter and comes up against the arguably contemporary difficulty of defining political action that emerged in the previous one.

The montage of this conversation includes the voices of Ayreen Anastas and Rene Gabri, members of the

Precarious Workers Brigade (PWB), Janna Graham and Robert Sember (Ultra-red), and Nick Couldry.

Lucia: Through exploring the notion of collective listening in the previous chapter, we talked about micropolitics and the possibility of imagining and creating a space for the articulation of collective speech in everyday life. This seems somehow concrete and feasible within small, self-organised groups if we think about the impact of feminist consciousness-raising groups as an example.

Claudia: But on a larger scale it gets more difficult. As we discussed in Chapter 2, within the Women's Movement something of a crisis occurred when feminists wanted to be more effective on a wider level. It was felt that small, informally organised groups were not effective for structural social change, and that there needed to be other kinds of structure to create a larger movement for small groups to feed into. It starts to get more complicated when organising on a larger scale. Nick Couldry has written about the organisational challenges of valuing and enabling voice on different scales.

Lucia: So Nick, how do you think it is possible to retain a plurality of voices on a macro collective level?

Nick: In terms of what would it be for voice [to work] on the collective level, there are no real clear answers, because once you get beyond the collective that knows each other then it becomes extremely complicated because you have to rely on institutions to hold voice and allow it to stay, and for others to come back to it. Then you get the temporal problem and so on... but within the collective it obviously involves everyone having the chance to give an account of themselves, if they want to and they may not want to. Silence is also a very important right: to be silent is to

speak by not speaking. Allowing that to be possible... finding ways of requiring people to listen and to register others peoples voice, allowing everyone to comment on each other's voice, allowing people to revise their voice and be free to revise and not be held to what they said before, it's a constant process of mutual friction and adjustability. It's an ongoing attempt to sustain each other's accounts and everyone's ability to go on revising their accounts of themselves in the light of what others say, it's this sustaining of the mutual entanglement that... is the bigger picture of voice. It's not about posting an update on Facebook.

Lucia: What do you mean by mutual entanglement? Reciprocity? Normally institutions are not good at listening even when they try to do it. The politics of listening sits uneasily with any form of institutionalization. So how can we have rules or practices which can tune into a plurality of voices?

Nick: You have to support that mutual interchange which is almost always closed off in any institution. Because they say that this influences people and so on. It's sustaining that openness to the process of mutually changing each other that is very hard and we don't really have names for that. It's not what was meant by collective because it becomes quite fixed and rule based. It's a broader type of social experiment and art might enact that, but again, that doesn't really have a name yet because it is certainly not going to be bound in the way that traditional art was bounded, but it might be recognisable when it happens.

Claudia: This possibility of an openness to a process of mutual exchange seems to be a key aim when we talk about listening in relation to institutions.

Lucia: Which of course gets more complicated when dealing with already existing institutions that have their own

ways of doing things.

Claudia: The different practitioners' examples we've been looking at – PWB, Ultra-red, and Ayreen and Rene – have created collective spaces and entities, where speaking and listening have taken place. There are examples of different modes of collectivity and group formation, some fleeting and temporary, others more long-lasting. These collective entities have all had different relationships with public space and institutions. PWB have worked with the ICA and the Whitechapel Gallery – both inside and outside the institutions. Ultra-red have worked across a range of institutional frameworks including galleries and local government...

Lucia: I think it would be interesting to hear from Ayreen and Rene about their experiences as they have been working with many groups but also with institutions. They have been long term hosts of an artist-run space (16 Beaver), they have been involved in artistic collectives such as e-Xplo and have done a lot of artists residencies in many different places, they have also worked as advisers for Documenta 13 and in art schools. Rene, I am interested to hear from you because of two important questions in relation to the possibility of shifting or embodying more than one identity, firstly, how to occupy institutional spaces, and secondly if an art space can be a potential field of action.

Rene: I think it's really a challenge to try to create a different context (within an institution). The situation is not always so easy that you can lure people in a way out of this... other channels that are more normative, dominant and determining encourage a certain kind of shallow experience of listening which is rigid and time de-limited. The way I see it, whether it's a classroom, or a talk in an art context, it's like a function. The representation of these situations are sometimes so much more important than what

actually happens inside them. So this happens even with the most well-meaning and committed people working inside many art institutions who are suffering because they see the wider circumstances and they are de-limiting their ability to even to create such spaces. It's very rare to create a different context.

Ayreen: There is no ability to listen to what they feel, what they feel they need to do. From the perspective of the maker, if you ask about art and how we want to experience and share things with others, I think about this wider field of listening which is not top down organized, it's very differently organized and its time is different, the duration is different, the relations are different. This is very hard to produce in an institution and although sometimes you succeed, I think our life would be much harder if we didn't have these autonomous experiences where we experience a different way of thinking, listening, whatever. Being together on many levels and not just on a discursive level, thinking about important things that matter to us and determining what those are and what the parameters for discussing them are, very simple things. How long in advance an announcement needs to be sent out seems for example a big thing for institutions as they are not able to get beyond this rigid framework, the regimented agendas. Sometimes we send out an announcement for the day before thinking, ok not too many people will show up, but it's fine, we will have a good discussion. Then to our surprise it could happen that a lot of people show up, so in our experience it's more about the energy that you put in, the care you have, the relations to others whether they are formal or informal…

Lucia: Can you give us a more concrete example, I mean of an institution you have worked with?

Rene: Our experience with Documenta 13 was a very rich

one because we were really internal to the process and yet in time, in discussions concerning questions of mediation, or conceiving of public programs or education initiatives, we realized that some dimension of what we felt was necessary, a less determined and more open ended situation of sharing experiences and processes could not happen in the main structure. So it didn't mean for us to abandon those common discussions, but it did require creating a parallel process or structure (*AND AND AND*) which could determine its own communication protocols, its own duration, the forms it would take, the kind of situations we would create, no opening or closing times, etc. But as with most of our experiences, this emerged out of a real need and with full engagement in a common process.

Another example is when we were invited to the Serpentine Gallery to give a 10 minute talk in the context of the Marathon[1] to a big audience. We didn't really think that's how we wanted to be heard or wanted people to hear us. It was not a question of numbers for us. So we asked for a room where we could stay as long as we could to have a discussion with people and produce a map about Palestine together through their words and speech. For us the creation of another time/space is really important for activating a process of listening to one another because I think the institutional time is the time of money, it's the time of power, it's the time of command. It doesn't mean that every institution falls under that and of course there are people inside of those institutions that could determine or try to organize differently, and we try to use our position as artists to open such situations. And I think that once you create that space/time, other actions and sensibilities can emerge. And after you have such experiences, it becomes harder to go back to normative situations.

Ayreen: When we are invited by institutions it is always important for us to overcome the separation between dif-

ferent realties by also knowing where we are. Another example I can give is the work we did together with e-Xplo in Sharjah[2]. We recorded the voices of workers there, knowing that this was not the only way to relate to the workers because of course their struggle or their potential struggle was important too. It's in fact important to talk about it in terms of labour, migration and rights, but to also try not to fix people to one thing but to see the artist in the worker as well. I am saying this in parallel to understanding the bigger situation. Making the recordings was an entry for us, a way to be able to connect to people and talk to them and to see their situation in a more fluid way. So it was not an immediately functionalized relation. Through this project we ended up having more intimate experiences, understandings, even becoming friends so it was not just about the recording production in itself.

Lucia: I worked (as a curator) with e-Xplo in 2003, on an independent project that was exploring the phenomenon of gentrification in East London. I remember that process of recording in the streets as something very engaging with the place. It seems this work in Sharjah was a further attempt to engage with place and people, but also to reach out and open up a relational space within the structure of a biennale. Personally, I have only once participated in a biennale context (Manifesta 7), and that took place in my own native region (Trentino-Alto Adige). Although there was a space for realizing something directly connected to local people and institutions, the process of continual negotiation with the appointed curators of Manifesta was totally exhausting and frustrating. In the end most of their exhibitions resulted in a totally alienating experience for me, as very little of the biennale's original claims, printed in bold everywhere, were reflected in any substantial change for the local communities. For example an old factory, originally used by a group of anarchists who were very active in the local area,

was refurbished to host one of the exhibitions of Manifesta. After the temporary exhibition this space was allocated to the Museum of Contemporary Art as storage space instead of becoming once more a social centre!

So when the opportunity of working with a specific community or group happens through an art institution, there is always an issue of accountability to be taken on board. And the question is whether the invited artist or curator is only responsible towards the institution who commissioned the project and/or towards the local community. What happens often in this kind of temporary framework, like the biennale is a situation in which the level of engagement with a community is normally measured by an institution through the number of participants and/or visitors for example. Artists on the other hand are often (over) preoccupied with the production of their own work and not necessarily (even) aware of their own level of implication with an institution. How to find a balance between the two poles is somehow tricky.

Claudia: Do you think this happens only within temporary institutional frameworks?

Lucia: No, it can happen in long term or even in permanent art projects. A typical scenario in this regard is the use of public art. How for example art has been used by local authorities in the UK to sanitize many industrial areas under their programme of urban regeneration, and how in short, art has been instrumentalised and used to justify an actual process of gentrification. What happened in the last ten years or so, due to the structural changes of the funding system, in particular that of Arts Council England, is a situation in which even the most genuine socially engaged practice has inadvertently internalized the values of neoliberalism by sticking to the rules imposed by certain models of measurement and evaluation. This often happens

when participatory art projects are seen as an easy solution for complex issues such as social inclusion[3].

Claudia: What about Ultra-red, Janna, have you had similar experiences with institutions?

Janna (UR): The most ordinary things like having food in the gallery are often the ones that produce the most conflict with institutions. It's quite interesting, everyone looks for the conflict on the level of ideology in its linguistic and performative assertions, in their programmes and in the artists that are selected, but actually so many of those ideological struggles take place on the levels of who is allowed to come in, how they can come in, under what conditions, what they are enabled or disabled from doing when they come in, what kind of food they can have when they come in, whether they can be paid in ways that aren't on the books... so much of the work of countering the bourgeois ideology of culture is on this micropolitical terrain.

Claudia: I'm also wondering what experience you've had within a wider institutional or community based context, for example with local authorities. What are the structures that allow or preclude listening? Can real listening take place at these sorts of institutions or is it just the staging of or the appearance of listening?

Janna (UR): We've learned this time and time over. Particularly the members of Ultra-red who have participated in anti-gentrification struggles. Because there are complex apparatuses for so-called listening within those structures of gentrification, we have had to negotiate how and when to engage with them, knowing that they are not actually set up as platforms for listening to voices but actually using that moment of hearing as the justification for the next step. This distinction between hearing (a physical act) and

listening (taking in what has been heard) is very important here.

Robert (UR): There is the cynicism around these consultation sessions, which often happen around gentrification or regeneration, which is: "we will have a consultation session and everybody will have a chance to speak and then we will make the decision we have already made."

Claudia: I was wondering about the "value form of participation" that you talk about in one of the thesis' of your booklet[4]. Is that what you mean, that the commodity form, is in the appearance?

Robert (UR): Exactly. And that's the term that is used in the thesis. It's the kind of closed unit. Someone has spoken and it circulates, and that's it.

Janna (UR): This happens also in the anti-racism work, maybe in a different way... When, for example, we were working in rural England on an anti-racism project we sat up listening sessions in different communities around people's experiences of racism. Some of these listening sessions took place in very small communities where racism hadn't been spoken about openly in 20 years and in which racist violence was routinely ignored in favour of a liberal, watered down idea of diversity. Politicians came out to those encounters. They often found the mode of listening to be too much, and immediately attempted to foreclose conversations, or re-route them towards diversity festivals and "positive" discussions. The people working with us found this to be a double violence. There is this kind of management of freedom that is quite central to processes of neoliberalism and how institutions, politicians, corporations understand the voice. It's really not about censorship in that sense, and the mistake that many people make in

over-emphasizing the voice is to say "well we've spoken". Or, "at least we had a place to speak" and to not actually attend to what the conditions of speaking and listening are in the wider context i.e. whether the structural conditions of the situation: what is said to rupture or re-organise conditions.

Another group we worked with, an anti-racism organisation, had very precise practices of speaking and listening which had come out of an anti-racism struggle in the 70s. It had been brought into the state's multi-cultural project and through that had completely changed their own practices of "voices". Where in the earlier practices they had been involved in much more collective organisation, by the time we worked with the group they were sending migrants out to provide testimonials of the experience of racism, then putting them to the side to speak to policy makers on their behalf. In a number of listening sessions we attempted to rearrange these hierarchies of speaking and listening, so that the leaders of the organisation had to speak in the same way and at the same level and for the same duration as the so-called victims. A lot of the listening procedures that we set up have to do with trying to alter dynamics of speaking and listening that are habituated through experiences of neoliberalism, a kind of conditioning of the voice to speak constantly, but a total dearth of conditions that enable listening to take place.

Lucia: How have PWB negotiated working with institutions?

Lola (PWB): An example we can give is our non-participation at the conference about Art and Labour at Tate Britain. We refused to accept this invitation because there were not the right conditions that were in line with our ethical code. However we agreed to attend the event as members of the audience. As in other, similar situations it was also clear

for us that we did not want to accept this invitation because we don't normally like to be on stage just to "perform politics", we prefer situations in which we can do an action, share or learn something from it. We decided to talk from the audience and use that space to announce the pay back campaign for interns rather to ask questions relative to the panel. As of result of this we were just shut down, the space for speaking was closed down…

Chloe (PWB): Normally we refuse invitations by institutions who organise paid events but do not offer a fee for presenting. It was a difficult decision, especially as when we spoke to the organisers they suggested we make an "intervention", turning it into an even more difficult invitation to respond to… After our campaign announcement was silenced, we were told (by the people who had invited us to "intervene"), to ask a question, so we asked about the finances of the event… We were hoping this might lead to a discussion about the real political economy in the room especially after a particularly abstract presentation, but again we were silenced…

Claudia: This clearly illustrates how certain protocols of speaking and listening can be easily embedded within an institution. There are very clearly defined roles. An auditorium, literally a "place for hearing", is set up for the audience to listen to the speakers on the stage. The space for speaking from the audience is afforded a different amount of space, time and ultimately of value and legitimacy. By attempting to speak from the audience PWB disrupted these very basic conventions and were shut down for doing so.

Lola (PWB): Even members of the audience were quite hostile towards us for disrupting the event.

Chloe (PWB): Afterwards we explained why we opted for

this action through a (public) letter to Art Monthly... You know, normally if we submit an article or a text, we use an "info box" to reveal the finances involved in the publication. So for example how many interns were involved, who got paid what and how many hours it took. We had an idea to do a similar thing for the event. We had been in touch with the organisers beforehand and knew that only the technicians and the curator were being paid and thought it would be good to be able to discuss it in public but...

Mila (PWB): Retrospectively I think that we could have spoken and been more strategic, we could have played the role more, just to be on the podium we could have had more legitimacy in relation to the audience... we felt like actually we could have done better... thinking in terms of strategy.

Lucia: This action did however have some kind of effect because the letter in Art Monthly prompted quite a bit of debate about exploitation within the art sector!

Claudia: Still, it's interesting to think about how the frameworks of conventions and norms are reinforced, when to speak, when not to speak – what is counted as an acceptable intervention or even as speech at all. It's interesting to see the defensiveness of an institution that stops any attempt at listening even in the supposedly open field of art. In practice it seems quite constraining.

Chloe (PWB): We were also involved in a project at the Whitechapel Gallery that was very tightly curated. We were given quite strict instructions about what we could do. We tried to respond to this by being both inside and outside the institution, running a photo-romance workshop in a space not governed by these rules.

Claudia: Are there other attempts we could talk about that have tried to circumvent these restrictions?

Lucia: We can go back to the example of *AND AND AND* given by Ayreen and Rene. As the letter of intent says, that space "reclaims the capacity of artists to speak for themselves and to construct their own discursive frames"; a space which allows "a multiplicity of voices and positions to tell and embody the story of art today" and explore "the potential of non-capitalist life", of "other calling, other doing"[5]. A strong emphasis of *AND AND AND* was on commoning as an action and not as an object. So the project as a whole can be seen as an attempt to imagine a time and a space that *activates the field* but also, in contrast to capitalist production *a field of (in)activities*.

When I visited *AND AND AND*, my experience was very different from being a mere spectator of Documenta, not only because I knew the organizers of *AND AND AND* very well, but primarily because this space was conceived as a semi-autonomous artist-run initiative open to whoever wanted to use it as such. Although this space was visible and open to a more traditional audience (the visitors of Documenta could see the physical space where most of the meetings were taking place) there were many activities including workshops, collective cooking, screenings, discussions and pure moments of conviviality and relaxation, which were going on most of the time. During the days I spent there I met new friends and talked to many interesting people, including local activists involved in the management of urban allotments. The feeling was that of taking part in a real social and artistic experiment which could continue after Documenta – or so many people like me were hoping! But as often happens within these temporary art frameworks, things dissolve very quickly after the "grand ball".

Claudia: Would you picture this temporary space as a potential political space?

Lucia: It is a very difficult point to answer. In principle I would say yes because under the rubric of art it is often possible to do things that wouldn't be possible to do elsewhere, at least so easily. An art space is *par excellence* a space of freedom if you think, for example, of the issue of censorship. When the most outrageous action, for example showing your naked body in public, can be called a performance or be seen as an art work, there is much more flexibility and openness in allowing this to happen rather than to immediately censor it as an act to cause public offence. Experimenting with forms of collectivity within an art context could also be much easier in smallish urban contexts such as a city like Kassel. If a group of activists had asked the city council of Kassel to run a social space for 100 days, could the gatherings of *AND AND AND* have taken place at all?

Irit Rogoff says that when art becomes "an open interconnective field", when the potential to engage with art is "as a form of cultural participation rather than as a form of either reification, of representation or of contemplative edification", then, the engagement with art can provide a potential political space. She calls this "a politics without a plan", a politics which does not have direct resonance in the world, yet can stage and enact another political space. She thinks that this form of political action is not ephemeral and based on speech as action but is also founded on "acting without a model" and on making "its means as visible as possible". What she is proposing is to accept the exhibition space in terms of Arendt's space of appearance[6]. I think it is an interesting proposition, but it does have also some limitations. If we embrace Virno's analysis of post-Fordist organisation of production and his critique of Arendt's notion of political action, this "open interconnective field" can

also resemble an empty stage for performing and enacting politics as a kind of productive value per se. Something very far from an act of radical disobedience or resistance.

Claudia: Yes, the difficulty I have is in thinking about a space of appearance that is not just an aestheticized space. It easily sounds like the kind of space that is purely about *appearances*, like the example Ultra-red gave of the value form of participation, where there is the appearance of participation or voices being heard rather than an openness to actually being moved to act on what has been said.

To me, the potentiality of the art space to facilitate a space for politics seems limited for a whole number of reasons, no less in the tendency to emphasise form over and above other considerations. One very obvious example is the hosting of Occupy at the Berlin Biennale which became more like an activist zoo, another spectacle to be consumed and in fact a creator of value in terms of cultural capital. By the time the Biennale happened, Occupy as a movement was already losing its momentum, with public spaces being cleared of protest. The possibilities for listening and speaking in terms of a mutual exchange was also much more compromised in the gallery space as this happened according to the parameters of spectatorship. Passers-by were less likely to join in.

That's why we are interested in groups that in one way or another cross the boundaries and are not just limited to existing within art spaces. Ayreen and Rene's project at Documenta 13 did at least question some of these boundaries, attempting to create alliances with groups of people outside the art festival, leaking out into the wider city to try to facilitate some other kind of social change.

Lucia: I agree, Occupy at the Berlin Biennale was a typical scenario of aesthetization of politics. So the risk to theorize the exhibition space in terms of Arendt's space of appear-

ance can be easily interpreted in the terms you have just described. But I think Rogoff's idea is based on different meanings of appearance. She speculates about art in terms of an experience that is not an individual reflection, but as the manifestation of various forms of collectivity. Rogoff pictured this as a process that might produce new forms of mutuality, or "relations between viewers and spaces rather than relations between viewers and objects"[7].

Claudia: To me, this sounds a lot like relational aesthetics. Emerging in the 90s this strand of art practice championed relationality and was developed as an approach to understanding the construction of collectivities, communities and relationships within an art context. Nicolas Bourriaud argued that this was a theory of form in which inter-subjectivity is the essential aspect of the artistic practice. There was a huge shift towards this kind of work in the 90s. Art then became an activity that primarily produced relationships with the world. For Bourriaud, the subversive and critical function of artistic creation is the creation of temporary collectives and communities that come together to produce the exhibition or the space it's in. The artistic intervention is aimed at forming models of action and being within the existing world, creating new possibilities.

Lucia: Yes, but what I'm talking about is very different, although I can see how it sounds similar. In the 1990s *Relational Aesthetics*,[8] suddenly became the main reference point for any kind of relational art practice, be it installation art or any other form of participatory art, but these don't have a lot to do with the examples we're looking at. It might be relevant to say that *Relational Aesthetics* was written by Bourriaud in response to the work of a specific group of artists who collaborated with him in the 90s including Vanessa Beecroft, Philippe Parreno, Pierre Huyghe, Rirkrit Tiravanija, Maurizio Cattelan. Although Bourriaud makes

this clear on many occasions, he somehow fails to state this in the introduction to his book! Many of the critiques that followed the English translation of *Relational Aesthetics* picked up on the close relationship of Bourriaud and the artists represented in his book with Parisian galleries. Not only did the spotlight fall on commercially successful artists, but it had a neutralizing effect in terms of critically addressing the issues connected with art market operations and the kind of mentality that this implies.

Claudia: Not only is criticality towards the art market neutralized. With relational aesthetics, the emphasis is placed on micro-practices of "intervention" rather than forming utopian or imaginary realities, and this is where it starts to become problematic. Stevphen Shukaitis writes about this really well in *Imaginal Machines*. For one thing, Bourriaud's relational aesthetics is very much contained within the walls of the gallery space. He's not much interested in what might take place beyond this. Also, he separates the micro from the macro in ways in which they don't have to be separated. For Bourriaud, there has been a shift from the creation of imaginary realities to micro practices of intervention. "Social utopias and revolutionary hopes have given way to everyday Micro utopias and imitative strategies, any stance that is directly 'critical' of society is futile"[9]. Artists therefore, should give up any hopes of having anything to say about social conditions on a large scale and instead be content with micro-interventions and practices. Shukaitis suggests that this "sounds quite similar to approaches ascribed to politics coming in the wake of 1968 and post structuralism, and so-called 'identity politics'"[10], a shift in politics from grand to minor, some of which we have discussed in relation to feminism. However, it seems obvious from looking at feminist consciousness-raising practices that it was precisely the linkage between inter-personal "micro" relations and wider social structures that

were really important and this is precisely what gets cut off and blocked by the containment of the gallery space in relational aesthetics.

Lucia: Bourriaud totally denies the legacy of feminism, environmentalism or for that matter any social/political practice which is preoccupied with social change. When discussing work which is about affective labour and conviviality, such as for example the work by Rirkrit Tiravanija, Bourriaud is much more interested in the formal gesture of offering food in a gallery space rather than analysing what kind of human interactions this gesture produced (care, affect and inclusion for example).

Claudia: If listening does take place within relational aesthetics it is often contained as part of some kind of game playing with rules and boundaries that are not allowed to have consequences or to have effects on real social conditions. For me, this starts to make sense of why PWB were asked to intervene at the Tate but were then closed down when their intervention tried to initiate a discussion about the real economy of the event. They could have perhaps been allowed a different kind of intervention, but one that was not about discussing social conditions of the event itself. So, any kind of listening by the institution that might result in change cannot be allowed to happen.

Lucia: No, this change will have of course a negative impact on the institution, for example diminishing its credentials!
 To come back to aesthetics issues, I would much prefer to consider the concept of connective aesthetics elaborated by Suzi Gablik rather than relational aesthetics. This is very much informed by a feminine perspective on care and compassion which she linked to a whole healing process. Although there are strong similarities with relational aesthetics, such as critiquing the individualism of

modernist aesthetics and considering the audience an active component of the work, connective aesthetics operates on a quite different ideological presupposition. The purpose to shift from the contemplation of art objects to the creative participation was seen by Gablik as a challenge to turn the politics of spectatorship into a politics of listening.

Rather than the public being the "unreal entity" that Bourriaud suggests, for Gablik it is made of a real community or group of people. What the audience says and how the members of an audience interact with each other is the centre of the artistic process, like in the performance of Suzanne Lacy's *The Crystal Quilt*. This is why empathic listening is considered by Gablik an important component of connective aesthetics: "Empathic listening makes room for the Other and decentralizes the ego-self. Giving each person a voice is what builds community and make art socially responsive". For Gablik the interactive and dialogical practice becomes "a metaphor for a relationship which has a healing power". This interconnectedness between the self and the Other, comes from a "feminine perspective", which according to Gablik, "has been missing in our scientific thinking, policy making but also in our aesthetic philosophy as well"[11]. She talks about the important of care and compassion.

Claudia: Healing is by its nature transformative – if something is healed it is changed and moved on from or at least accepted – in a therapeutic sense being listened to can definitely do this. This does fit with some of the things we have been talking about in terms of creating change.

Lucia: I think a common point between our three examples is the attempt to inhabit institutional spaces through collective processes and direct participation. So there is a similarity with what Gablik wrote in the mid '90s. However, in our examples there is not so much of an emphasis on

listening as a metaphor for healing. With our interlocutors we have rather discussed it in terms of political therapy, especially in regard to the work of PWB. Gablik's language resonates of course with many of the experimentations and concerns of the '70s while here we are talking about the impact of neoliberalism and how institutions deny listening and voice whilst at the same time being seen as proponents of freedom of speech.

Claudia: Yes, but I think there is more than that though. There is something about existing both inside and outside the gallery space, the institutions of art that is also important. As we've said before, being both inside and outside the discipline of art allows some measure of freedom – it can be very easy to be pinned down, packaged up and sold. So to be slippery in this way may afford some space to operate differently and to try to affect some kind of social change or at least a process that might lead to that. I also think though that this can make practices a bit opaque and quite difficult to talk about. I'm thinking here of Ultra-red, where it's hard to see what's actually happened if you didn't participate, let alone evaluate its social or political efficacy.

Lucia: I think it might be worth bringing Nick Couldry in here to talk about other kinds of connections between art and political praxis. I am interested in some of the points made by Couldry when he was talking about art and democracy and John Dewey. Could you elaborate on this Nick?

Nick: I've always been interested in John Dewey's work and his thinking about democracy as a social practice. Democracy is not just a political structure where we occasionally vote and somehow we sort out problems, it is a way of living together as if we mattered to each other. Very interestingly John Dewey saw art as a way forward in the 1930s, at a time of tremendous political despair in the States with

starvation everywhere and no employment. He saw art as a way forward because it enabled people to imagine other ways of doing things, it authorised them to speak about what they were not authorised to speak about. Of course that insight has long since forgotten, a lot of it went into education and whatever, but I think it's the time to bring it back...

Lucia: What does John Dewey mean by art as a way forward? And what is the challenge of bringing this back today?

Nick: The basic idea is that art is potentially a way for re-hearsing for democracy, it's a way of living *as if*, in a way that allows things to be acted out that just absolutely cannot otherwise be acted out... So you need a certain space as if where you can bracket and recognise those important differences for the purpose of imagining a common future and different ways of doing things. It then has to reconnect to resources and whatever you need for that imagining.

You can't have politics without that bracketing and imagining, which is an abstraction. It has to be respected for the value of abstraction it gives. But then you need articulation, an old cultural studies concept, which is the key thing that is very under-developed in political theory... So you need to think about what it is to articulate the moment in the gallery, the moment in the collective, the moment at the Occupy, what will be the links to build between those moments so they continue to be connected and feed into each other. How also it becomes a stable thing that people can refer to, above all for those who know nothing about it but are looking for something different. In the middle of my book I talk about how you can have voice in large organisations. It is not about everyone shouting at once, so you have to think about the stable arrangements that allow over time a lot of voices to be valued in turn under certain conditions. These are very complicated things to think about.

Claudia: So this bracketing of space also has to allow for imagination and not just play within a framework of rules. I think it would be interesting now to turn to the question of social media. The Internet has in some respects also been perceived as a kind of bracketed space. At its inception during the 90's, it was viewed by many as a potentially liberatory space for ways of being, and even now with experiments in open source and peer-to-peer production it is still seen to some extent as a space for trying out different ways of doing things. Much has been made of social media's potential for participatory politics. Platforms like Facebook and Twitter are seen as potentially enabling new collective modes of organizing, however, I don't think that these new communication technologies are automatically political. Nick, do you want to say more about this?

Nick: You could say that the groups or the people who are on Facebook are profoundly un-radical and non-political most of the time, and that's Jodi Dean's argument in her book *Blog Theory*. Most of the time politics is explicitly bracketed out by the framing of the programme or the platform: it frames out politics, but every now and then people break through that because they just have to. Just as they rush through a street sometimes, which is not meant for politics, and they just have to gather together, that doesn't tell us anything about whether the streets or the platform or Facebook normally supports politics, it just so happens to be happening right now there because it has to for other reasons. So, on the one hand, it seems easy to do collective stuff through art, but that makes it even harder to work out when it's really making a difference. When it really is being true to those values and when it absolutely is not. Making those distinctions and sustaining them in a group is really hard. I get the feeling that it's actually harder to do the type of work you want to do now than it was perhaps in the 1960s or 70s when in a sense many gestures were *ipso facto*

political because they had just never been done before.

Lucia: It's interesting to think more about the role of social media in collective and political processes. If we move from physical institutional spaces to the immaterial space of the Internet, we might look at how the virtual and physical spaces overlap and whether any effective listening can go on there. Both PWB and Ultra-red use internet platforms as part of their practice. The PWB blog seems to play quite an important role, posting tools, research in progress and information related to the different actions. What do you think of the Internet? What do you think about web listening, do you think it can be a form of collective listening? For institutions like public museums, the online platforms are often an extension of their space for showing their collection, increasing access to a wider audience, advertising their programme. It seems to me that for activists social media is a very important organising tool.

Tanya (PWB): I was thinking about new technologies and how a kind of imaginary solidarity works because we no longer just exist in a physical world. There is this huge imaginary space and experiences of people being together through listening to what they tweet about, responding or not responding to. This is a totally different space of listening, but there is something very intense about the collectivity there, of that virtual experience of the internet.

Martha (PWB): I suppose it is about either groups that have some pre-existing solidarity or being in the same time space where they listen together. I am thinking especially temporally in terms of affinity on one hand, and on the other hand about something cyclical that has been collectivised, some sort of connection, like reading emails. I think listening through emails is such an interesting observation... listening all together and through feeding back can solid-

ify your collectivity. Through that gesture by saying: yes I have heard, I listened, I understand where things are at!

Alex (PWB): I'm not sure how far this virtual listening goes. At the end of each [social media] campaign there is a demonstration or an actual gathering. In the end, you have people coming together and raising their voices. This is where the force and power comes from.

Tanya (PWB): A lot of listening is now happening through emails, inside those conversations... After the Future Interns action at the Serpentine Gallery for example, we started to get all these letters from people. They gave testimonies and complained about working conditions and so on. These kinds of discussions happen privately, in email. It is not a very active form of protest.

Mila (PWB): This is an interesting point, it seems quite fragmented and private.

Tanya (PWB): Listening does not start in the moment when people are coming together but starts on the level of intuition... a kind of premonition...

Alex (PWB): I don't think that this is actual listening. Especially when people read and skim through emails. For me, real listening happens in a physical space. I think an email cannot provide a psychological space where you have an input, because it is such an administrative tool that you can use for labour, for creative work, for information.

Claudia: Administrative tools are what make up institutions. When we talk about something becoming institutionalized, it is the systems that we have created to relay information, organize people or labour that start to become rigid and unresponsive. Although they are created to be

neutral, they quite often aren't, as Nick Couldry argued. They often actively frame out politics and the responsive kinds of listening we've been talking about.

Tanya (PWB): I am really coming from the experience of taking part in the protests in Russia, and the crisis and also the student protests, and I am also thinking about the Arab Spring and the Ukraine. There is something here, a different kind of listening being produced because of the crisis and digital information.

Mila (PWB): You have to make a distinction between actual listening and virtual listening.

Lola (PWB): What Tanya has described is perhaps a kind of rhizomatic listening which does not imply to be all together in the same space, but rather being able to tune in to certain moments. It needs to be said that the way PWB normally take decisions is through meetings and not by emails anyway.

Lucia: I also want to ask Ultra-red what is their relationship with the Internet. If this can be a space for the relocation of material produced in a physical space or with certain constituencies, how does it work Janna?

Janna (UR): Within Ultra-red, the Internet is an archive and a platform for sharing what we have done. At a certain point we made a shift to putting our work online rather than working with a record label for distribution, both because of the much vaster numbers of people who access them but also so that all who have taken part in projects have access to the material. We are accountable to those people and therefore privatising the knowledge we produce together makes little sense. As for the wider questions related to institutions, when we understand

our accountabilities as lying with the constituencies we work with and the political process we are engaged in, concerns about art and its autonomy, its circulation or disconnection tend to be quite minimised. Although we are putting cultural objects into the art world from time to time, these are objects in passing, in service to a process, with a trajectory and process in which we are not the only protagonists. So if somebody listens to a sound project we have made, it doesn't fill me with anxiety when the act of listening is disconnected from the site in which it was produced, when there has been accountability and utility for the group we have worked with to create it in the first instance. When the group has, for example, decided that making the sound object public is something they have deemed important to our/their particular anti-racism struggle, or at least decided it is useful in securing resources for some other part of the work, then I (and I can't speak for everyone in the collective on this), feel less concern about the question of dislocation.

My degree of anxiety about the art world is precisely in proportion to the degree the process is accountable to a particular constituency in a struggle. When the structural conditions of our engagement with the art world curtail this kind of engagement with struggle (through lack of appropriate time and resources, imposition of frustrating conditions, self-obsession, abstraction or exclusion of those we are working with – all of which we have experienced), our experience of alienation and anxiety mounts. In listening sessions we encounter this alienation frequently amongst art students and curators who do not have these relationships of accountability beyond the art world in place.

Lucia: This brings us back to the importance of the physical space but also to what Nick Couldry has been writing about voice in the context of neo-liberalism.

Nick: Physical space is very important. Some of the academic writing that is starting to come out about Occupy is reflecting on it. For example the work by Jeffrey Juris who was involved in New York, draws on social media and the importance of Twitter. The most important point about Twitter is that it drew people to gather together with a common purpose in sight of others and sustained that. Going back there, to draw others in, it was fundamentally about space, the re-organisation and the space of the city.

There is also a lot of talk about "the network society". Castells and others and it obviously has something going for it because networks are important. There are new types of networks for doing new things, but I think there's a big problem with that type of work, and I talk about it in my book. My argument is that a network society is an oxymoron, because a network is not a society. You can leave a network anytime and no one gives a damn, they don't even know you have left. A network is really not a society, if we pretend it is, it is profoundly misleading. A lot of the talk about the difference networks are making, Castells and also, I'm afraid to say it, much of the admirable Negri and Hardt in their book *Multitude*. When they come to talk about the social – and I'm sure you are interested in what they say about it – and in the way that we collectively create new ways of living, they actually talk about the social in very spectral terms: it is just flesh, this social flesh with no practical details about how we build that flesh except they say magically through networks. We are all globally in this thing, there is no way we are not, yet there are some amazing networks linking people from India to South Africa but they were happening in the 19th century against slavery through much slower means.

The thing is you've got to think about the social contexts, the spatial contexts in which people receive the energy: the outputs that come from networks. It makes a big difference whether people are linked into a network

sitting in a shared space, or where they've got no shared space, two kids, two or three jobs and they have no one who respects their ability to do anything valid. They probably don't even know that this network space is potentially there, but all that is forgotten in the grand rhetoric about how the Internet is changing everything.

Chapter 6: Ethics of Listening

This chapter focuses on the ethics that paying attention to listening might create. It looks at what is involved in creating conditions for listening and the conditions under which voice might be produced. Feminist consciousness-raising created safety to speak through non-hierarchical women-only groups and produced a particular ethical perspective. Listening is to be considered as an integral part of a reciprocal dialogue alongside speaking, neither as an isolated practice in itself or as a mere receptacle for speech. This allows for a shift from the heroism and performativity of solo political speech towards a more intimate but no less powerful register based on interdependence and relationality. In the absence of hierarchy, care and responsibility emerge as overriding concerns. These issues are examined by our interlocutors through attention to those things that might easily get passed over: sustenance and nourishment, connection, care and trust. In asking how listening might develop these conditions, questions of time and temporality are also raised: how temporal modes of action and activism might differ from that of organising, how much time it takes for trust and safety to develop. If time is taken out for thinking and analysis, how might this affect action? Responsibility can lead to calls for accountability. What are the consequences of this? This section explores what this means in relation to the individual and group experiences reported by our interlocutors, especially in the context of art spaces and community activism. This call for a reflection on ethics and responsibility also reflects on aesthetics in a particular way. How formalised should we make conditions and processes of listening? Is it always necessary to codify listening processes? Other perspectives on what and how we listen might also need to be taken into account with, for example indigenous modes of listening that might call for a sensibility that does not adhere to Western canons.

We might need to allow for silences and hear things that are not necessarily spoken, spaces and silences between and beyond speech.

This constructed conversation includes the voices of the Precarious Workers Brigade (PWB), Janna Graham and Robert Sember from Ultra-red, Ayreen Anastas and Rene Gabri, and Nick Couldry.

Lucia: In *Practices of Listening*, some of the members of PWB referred to listening as an action through which several precarious cultural workers gathered together to share testimonies about exploitation and gradually organized themselves into a collective. The moment that catalysed this gathering was for most of the people the tribunal organised at the ICA in London, in 2010. It is important to say at this point, that anonymity has been pivotal for PWB in order to create a safe space for people involved in various struggles. And although not every single member of PWB has to respect this principle, this has been a strategy within the group, particularly in regard to public actions and with the issue of authorship in publications. Perhaps we can continue this discussion and talk more about this issue of safety in relation to listening. Alex came out with a very important question which will be good to bring up here again.

Alex (PWB): How do we create the space that can make listening possible?

If you have a situation where everybody listens to/hears each other but you feel that what you are saying is not respected... and if this mutual understanding of listening and speaking (this safe space) is not created, then listening is not possible.

Maria (PWB): I think listening has a value as an experience. When you really listen, you validate and acknowledge the

person's experience... and it validates the experience of who is speaking (not only his or her own words)... However, you can get stuck in the same conversation with a friend who repeats the same thing over and over again, and even if you listen carefully, it does not necessarily help you or them to do something different, or to see things in a different manner. Maybe there are more ingredients that need to be added about the kinds of listening we are willing to do when we pay attention to others... and also there are other kinds of listening that are more associated with action.

Lola (PWB): What you are saying makes me think about techniques of listening and different forms and devices of listening. In a less literal sense, listening means to allow the other person to speak, and then you can argue that the action, that speaking, is speaking out. And this is related to the situation which we were talking about before: giving testimonies and the act of speaking out in public. I have the feeling, when talking about action, that this is an action that probably goes beyond the simple act of speaking out. For example, we arrived at this kind of discussion when we were at London Occupy and we were dealing with the issue of organising and how to think about actions in a different way. Political organising is possibly linked with techniques, strategies, different ways of listening, and not necessarily with becoming a union, or inhabiting a model that is already there.

Amy (PWB): Yes that's right... but it always depends on the context. I think we do a combination of these things. We speak out – the whole Parrhesia thing, where we are not supposed to (to say the truth, to speak out), or where they try to shut us down, or control us or whatever. There might be a platform for listening, but it is clearly very tightly controlled and structured, where the listening is set up in a proper way to be managed or just stopped right there...

Or a typical context is when people say, "Ok, great do your stuff!" and then that is the end of it and everybody goes home and maybe there is some kind of catharsis... but certainly there aren't any changes that come from that... Politics without consequences. What we are partially talking about is listening and speaking that picks up, that opens up, that leads to consequences.

Lucia: I think Rene was saying something similar when at the beginning he was talking about Walter Benjamin and a kind of ethical dimension attached to storytelling. He was talking about listening as a double movement, as an action attached to order on one hand, and on the other as the moment in which we take in what we have heard and decide to do something with it. Rene, would you like to add something to that?

Rene: There are a lot of different levels of responsibility. I can see from an artistic practice point of view that people could take that idea of creating certain conditions of listening and then kind of fetishise that. You would spend incredible amounts of resources, human energy, labour, this and that to create this immense experience in which one could finally listen to somebody in a different way. But sometimes I feel like: "oh well this video isn't the optimal situation to have created as I was too obsessed about that scenario." Or: "perhaps I could create a more forceful situation where one could maybe enter into it..." So I don't think it is necessarily a technical or formal issue...it is not a question of creating an exceptional space. I think it is more tied to the kind of wider context in which you are doing something and what matters is how you situate it.

Claudia: For Ultra-red, listening protocols seem very important in terms of working with groups and within the collective itself. Much of their practice seems to have its

roots in C-R. Robert and Janna do you want to say more about these protocols, where they come from and how you use them?

Robert (UR): Yes, in fact I've been really looking forward to this conversation because I've been waiting to hear about the research that you've been doing around feminism and C-R procedures, because I've been going back to some of those original feminist textbooks about how to organise consciousness-raising groups, their protocols and procedures, which are just brilliant and beautiful.

Janna (UR): Yes, sharing the protocols and the processes of our listening sessions is very important... We send dispatches after we've done one, we talk to each other about what happened, we talk about how different kinds of protocols for listening change dynamics. What is produced by those protocols, how they are resisted. How they are reshaped. How they are conformed to, and the conflicts that arise from them.

Claudia: How do you see listening in terms of political and community organizing?

Janna (UR): In the art world, it is a significant gesture to demand consequences at all. Within activism and community organising, there are differing theories and practices. Saul Alinsky's style of organising, crudely outlined, is a method for entering into a place, identifying the organic leaders, calling on those leaders and training them for action, coming up with a common goal, winning something and from there something else. It is a rather precise procedure. Whereas in community organising based in popular education, the first step is often a listening exercise, then the production of objects for reflection and analysis, and then listening and discussion again. If you read Chapter 3 of

Paulo Freire's *Pedagogy of the Oppressed* – which we've read a lot with different groups – the process of codification and decodification moves people into a deeper analysis of conditions before acting upon them. This can be as much an asset as a frustration. But Freire, like many feminist collectives, is concerned not only with the action that is achieved but also with the relationships, affective bonds, micro-processes and the possibility of taking risks together. Of course you can move into action very quickly, but it is not often sustainable and also quite risky for those involved. There are moments when that is also quite suitable as an organising practice, and there are other moments when it is not.

Claudia: That sounds like a sort of critique of activism as being perhaps too fast a response to crisis, with organising, on the other hand, being slower.

Janna (UR): Exactly, the long haul. It takes time to listen. Freire makes a particular distinction between problem posing (education-analysis plus action) and activism (action without analysis) which is important. Another problem within what we might describe as activism, is also the privileging of heroic actions over less visible and audible ones. This is a matter of narrative as much as of political process. There is an essay by Thomas Keenan called *Fables of Responsibility* in which he recounts the 1984 Montreal AIDS Conference where Tim McCaskell took over the microphone. His narration of that event, in the name of making a Rancerian argument about the performativity of speech, places emphasis on the heroic act of taking the microphone which "changed the face of AIDS forever" … For me this essay was problematic given the accounts that we had heard in our multi-year project listening to the aftermath of AIDS activism twenty years later, where attention to the effects of the crisis revealed the reorganisation and the conditions of activist work and its trajectory into the AIDS-industrial

complex. The analysis also seemed to betray the very important aspects of AIDS organising that emerged through the influence of civil rights and other preceding movements, i.e. to put organisational questions at the forefront through regular meetings, and a culture from which direct action could emerge and to which it could return. In social movements, as in art, there is a problem around the recurrent desire for this heroism of the speaker, the speaker who "shifts the game".

Robert (UR): And this is where feminism again is such an incredibly important corrective to that. And it's so great that you said that, because I've been doing that with my students a lot by saying heroes are a waste of collective time, resources and energy. We do not need heroes. We need organising, we need movement. What a hero consumes of the collective resources is just so excessive. And of course so often the narrative is "waiting for the hero", that messianic notion of waiting for the person who is going to come. And so a big part of this project is to take every single narrative that people produce as the act of the liberating hero, and to say "let's look at the women behind that figure". This is one of my critiques of Freire, in a certain sense.

Janna (UR): And all the wives, assistants and student collaborators of the radical pedagogues, whose names are never mentioned.

Robert (UR): Exactly, these accounts of the extraordinary work and innovation that arose from them. This is why Ella Baker is one of the most critical people at the moment for me. She is heavenly, huge. But I wanted to also say that a non-negotiable and essential ingredient to this work is accountability to a constituency. This begins to bridge into this question about the internet or these sort of listening venues, because this kind of listening we are talking about,

which is not the value form, arises out of an accountability to a constituency. You must, in a way, return to your constituency and be able to report to and inform them of the actions that you've taken. Which is for me the kind of scene of listening, the collecting together, the gathering of the face-to-face reporting, of accounting for your actions. This is so absolutely important.

If I could – maybe a bit prematurely here – introduce the notion of affect into all of this as well, which is so critical to feminism, and for me it is such a crucial element which is often un-spoken in relation to popular education. I take very seriously Freire's constant references to love. And of course in psychoanalysis this transaction of love is so important. So the question of affect and as part of the register of the voice, is critically important.

Janna (UR): And also affect in its relation to intention. Freire has almost very crude distinctions, but I really like them, where he's talking about where literacy takes place, and how communication takes place. He talks about the kind of communication that isn't really communication, that has always love and an intention to follow through the act of listening. Whether you love the work of anti-oppression, whether you care enough to continue on from the moment that you've entered into the conversation, whether you have a radical openness to what you hear, are the affective conditions under which this kind of radical literacy and dialogue can take place. I think this is really incredibly important.

Robert (UR): He uses very evocative language. The Right is only interested in necrophilic language, which is about deadness... Whereas a revolutionary struggle is conducted with the kind of passionate love for life, and that one listens too. The listening is constituted or invested around that constant renewal of energies.

Janna (UR): And this is crucial to community organising, and also to socially engaged art. The mode through with which you enter into conversations with people is as important as what is said in those initial moments. Did you have a cup of tea together; did you smile at each another; did you share the stakes of a struggle? These are the ways in which the investigations undertaken by Ultra-red begin. When we did the project in rural England, we spent six weeks drinking tea with people who had experienced racism. Before we sat in a large encounter to talk about racism, there were many micro encounters. There's a whole invisible affective element that happens in those projects that makes it quite difficult to replicate. It's not a model as such, although there are different protocols that focus our attention to affect. I agree with Robert that this way of working is indebted to feminist organising practices: the labour of the cups of tea, the decisions made in the organisation of encounters, the affect created, these are the conditions that make a collective analysis and action possible.

Robert (UR): It sounds like such a footnote, but these kinds of materializations are so critically important. Which is why I love reading these feminist instructions and to know how do you make a consciousness-raising group. You read them and the most mundane and ordinary details get attended to.

Every Ultra-red event has to have food. It's critically important that there is nourishment, in this most ordinary way. It's part of a fundamental gesture of hospitality, and a kind of materialization of respect through care and conviviality, the livingness of things together. And also marking something that is more than labour, or more than aesthetics. But when we work in art institutions, bringing food into the gallery is often the place of greater struggle. Over and over we encounter this: "No, you can have food here, but you can't have it there". The boundaries between

where food can be and cannot be eaten in spaces of art, and which kind of food, illuminates the context in such a profound way. These very ordinary things help to map the terms of the collective experience in some way. Again, this is what feminism says, and we must pay attention to it. Logos must always be reinserted into these very ordinary processes of love and care.

Rene: Some things that are becoming clearer in our conversation are the need or the necessity to really think about the conditions of the listening and the conditions of what is allowed to be even heard. What kind of time is given and what kind of situation… I don't want to be too generic about it, but let's say that there is a time that is production time, and a time that is re-production time. So we live by and large, especially in institutional spaces, in productive time. They are organized around a totally productivist logic and so, if you were able to see these places from the re-productive logic of re-producing ourselves and our sociality, the time of that could be very different. For instance, the food or the things that one could do in those spaces to actually nourish each other. The general relation to what we are doing is about producing knowledge or producing new ideas, or trying to create a space about how we want to live together so that the object of knowledge is not separated from a general reflection. But once it gets isolated, it is just about production or so I think.

To go back to the issue of responsibility, there's also like an ethics to listening in a sense… it is not an inquisition, or an inquisitory mode. In a way, the listener has to also allow for silences, and hear things that are not spoken. This is the attunement part of it. Sure, it has the risk of sounding metaphysical or something like that, but I think it is a process that for us became more explicit in an unworkshop we were doing with Leon Redler. It was around the politics of small groups that Jakob Jakobsen organized in

the context of *AND AND AND*. It was really an experience because we broke up into groups and we came up with some questions. The central question was to what degree do things have to be articulated verbally and in writing [in order] to have a sense of a situation. I think listening can be a practice or a way of entering that. It is somewhere between the written and the un-written that is also more open to language.

Ayreen: Yeah, and we have had discussions during *AND AND AND* about what is spoken and unspoken in relation to this question of protocols... Does everything have to be spelled out, spoken in language, or are there other ways to find out? If I enter a space, how is everything organized? Do I have to make demands too? Do I need everything now? I need to know how all this is organized and how do I do this? Or is it some other process that one undergoes to be able to be part of a group or a community or so, and we have had different experiences of entering let's say common spaces or communes. When you go into a commune, you are very careful because you want to approach everything slowly and to respect things, then maybe you can be part of it or slowly you can enter into a conversation and feel the space, but it is not a demand from the beginning. To understand can involve taking time, and finding a relation to a way of life. Different communes have different rules and ways through which they started and how people are living together.

 I think the question of culture is also important if I think, for example, about Native Americans who have their specific cultures of speaking and listening. I think about their sensitivity which is beyond human interaction, beyond listening or communication between individuals. That is an interesting point to learn from, because our listening can also be beyond the anthropocentric view, so we can also see where language recedes and other things can be felt...

Lucia: What do you mean exactly by "beyond human inter-action"? It sounds quite metaphysical.

Ayreen: I mean another sensibility I have observed which is different from the colonial subject who has language under their command and in a way that is all too comfortable. I can give you an example, or tell a story. When we went to Australia, we tried to meet an activist, an important person in relation to aboriginal land claims and politics, his name is Marundu Yanner. The people who spoke to us about him didn't know where he would be, the time and place were vague, an area encompassing much of North Western Austrialia... But we eventually arrived at his door. He was sitting on a hammock and we wanted to speak with him, learn about his experiences, struggles, and perspectives. He said: "Sure we can go hunting together or we can go fishing." We said: "Great, but where, when?" He replied: "I'll find you." So there was this kind of anxiety that we had to find him and record him, and we ended up in waiting for days in this little place. Until we finally realised that in order to hear him, we would need to make a more normal interview, but that is not what we asked for, nor was it what we wanted. And guess what? A couple of years later the recording was stolen when our apartment was robbed. So, this is a metaphor for us, there is a lesson there. The hunting or fishing never happened and although we managed to speak to him and make a recording, what remained with us is this image of a different sensibility that we don't have in our time. We cannot listen but we have to listen somehow; and so we listened to all the stories his wife told us on the way, how the police organised a football match in their children's school by day and harassed their family by night. This is really like the relationship between the coloniser and the colonized. An example of someone who refuses to be colonized in terms of these other relations to sharing time, like going fishing or hunting, and has instead

a relation with the land, that is more about responsibility and not about property.

Another example I can make is when we had a meeting in the time of Occupy on Native American perspectives at 16 Beaver. It was amazing because at the beginning of the meeting one person started by saying thanks to everything, the people who built the walls, the roof, the windows, the earth, the sun. It was very moving and it was a kind of listening that made you feel connected to where you were standing, but in a very different way. In the end it is about helping each other to connect to where we are rather than being isolated, but in a very aesthetic way, with a different sensitivity, and a different sense of politics, of who is part of this political community we construct.

Lucia: Nick, I know that you have also been reading something about a Native American perspective that might be relevant here.

Nick: Yes, the reference is the book *Radical Hope. Ethics in the face of Cultural Devastation*, by the philosopher Jonathan Lear. It is about a particular Indian Chief who survived the destruction of his land and the whole way of life that had given him any meaning. So the destruction of all reference points in terms of which everything he valued had a meaning. This person survived into a new era where you couldn't be any longer an Indian Chief, but you could still preserve some of the rituals. What is interesting is how that person survives and what type of hope he had in order to be able to survive. Lear argues that this person had what he calls radical hope which is "hope [...] directed toward a future goodness that transcends the current ability to understand what it is"[1]. In other words, hope that there would be at some time a ground for hope in the future, but the ground could not be known. And it strikes me, although we are not in a period of absolute genocidal destruction,

that we are facing a phase where there is a shift into a different type or way of organising. Things which we took for granted, a certain type of academic life which involves a certain type of freedom, a certain type of aesthetic practice which was free and not entirely encumbered to market and state, certain types of professional practice are dying, are being taken away. We don't have a ready language to describe that and the reason for that is because everything is being taken away at once, and yet we are still going on. And there is a great phrase where the Indian Chief asks the question to the philosopher Jonathan Lear: how is one to face the reality that is coming to an end because your very tools are being taken away, your hopes of being an artist of a certain sort no longer seem to make sense, no longer seem to fit with what others want to do. So how do you find a tool for dealing with the fact that you have no tools? Well, you have to stand right back and build something. So radical hope is an interesting idea because it is hope about hope. Again, Ètienne Balibar is talking about the need for a politics about politics. We need to completely rethink what politics could be, and in a time when Europe is no longer working democratically and so on and so forth. This implies to think about a politics about politics, hope about hope or art about art. And if in fact you are deciding on an anti-art stance or a stepping back or withdrawing from art for a moment, this brings to the foreground the question what art could be and to understand that you have to listen to the silence in the space that is left by you withdrawing.

Chapter 7: Resonance and Recognition (or the politics of listening)

By bringing theory and practice together in this chapter, we explore how different kinds of power structures, both hierarchical and horizontal, might produce different kinds of listening. *Resonance* and *recognition* are terms that offer good ways of exploring certain politics of listening based on reciprocity and mutuality. Who is doing the listening and how? Recognition of and by whom? There are also questions of value, for instance, how certain kinds of language are deemed legitimate or illegitimate, to be listened to or not. How do top-down political structures use listening as techniques of power and control and how might other kinds of organisation enhance forms of solidarity and mutual recognition? In talking to members of the Precarious Workers Brigade (PWB) and Nick Couldry, but also drawing ideas from Cavarero, Bickford and Lonzi's work, these questions move into the context of art and institutions, feminist creativity and political organising. If we think of listening as an act, what is its relationship to action and agency? How can listening potentially create solidarity, but also play a role within disagreement and spaces of inequality? If listening is affective labour what happens beyond a group that trusts itself? What happens if reciprocity becomes difficult? And, what happens as we move from semi-private to more public spaces, how does listening work? Can reciprocity work in this context? We start by talking about solidarity.

The constructed conversation in this chapter includes the voices of Nick Couldry and members of the Precarious Workers Brigade.

Claudia: We have touched on listening as something that is to do with care and empathy and seems to go in some ways, towards building solidarity.

Lucia: How might we think further about solidarity? Solidarity is one of the action points of PWB, Nick Couldry has also reflected on solidarity in his book by looking at the work of the philosopher Axel Honneth.

Claudia: Axel Honneth has written about solidarity as a form of recognition.

Nick: When I was in the preliminary stages of writing my book and really struggling and not knowing where to go, Axel Honneth's book *Disrespect*[1] was very important. It really brought together a lot of writing linking issues of class and inequality and the problems of democracy. His notion of recognition has three levels: the recognition of each other's body as something that needs to be held, protected, loved cared for; the moral level where we have to respect each other as reflecting moral agents who need to struggle to live; and thirdly, to recognise each other's ability to make a concrete contribution to a material community, as he puts it. Unless we have those three, we're not recognising each other. We are mainly talking about the third one here because that's the one closer to politics…

Claudia: This is also the level that relates to solidarity. That is to say, the mutual recognition of our and others' abilities to create a concrete contribution to a "material community." Honneth defines recognition as a process by which an individual might recognize themselves in a collectively produced voice. So it is the mutual recognition of our self as valuable and of others' value to a particular community.

Nick: So the way in which Honneth talked about recognition was an important thing in general because it's a kind of tool kit. It takes apart a really complicated thing and splits it into levels which we can then start thinking about, and seeing the deficits of recognition everywhere.

Claudia: In terms of solidarity, Honneth describes it "as an interactive relationship in which subjects mutually sympathise with their various different ways of life because, among themselves they esteem each other symmetrically."[2]

Lucia: This symmetricality seems to resonate with the reciprocal nature of speaking and listening that we have been looking at.

Claudia: For example the recognition of value that Robert spoke about in relation to the work that Ultra-red did in Appalachia. Solidarity is the term that Honneth uses for a cultural climate in which the acquisition of self-esteem is possible. One is given the chance to experience oneself and to be recognized in the light of one's own accomplishments and abilities as valuable for the common good. For this to take place, some shared concern, interest or value has to be present. Solidarity as mutual esteem and recognition of value can exist within a boundaried group but also across social boundaries or between groups. The creation of new solidarities might occur when something happens which allows subjects to esteem one another for things that had previously been without societal significance.

Nick: Honneth has written great work on what he calls the de-symbolisation of the working classes, how for a long period the language for describing people suffering was literally taken away from them, decade by decade, so they could not speak about certain things and they can't speak now.

Lucia: What do you mean when you say that a language has been taken away from people?

Nick: Because certain languages became illegitimate, they weren't allowed on the media, you couldn't talk about class, inequality or not in the same sort of way... You can't

talk about certain forms of taking power because they are of course absurd, ridiculous, no one thinks about de-symbolisation… it's not just individuals that are not recognised but certain whole world views that are not recognised.

Claudia: That reminds me of what the early feminist consciousness-raising groups were trying to articulate in departing from a condition of muteness. When women started these groups and started talking about topics related to their everyday lives, C-R groups were dismissed as not relevant, not political, but rather being therapy, you know… With feminist C-R groups, women's personal experiences had not had wider societal significance. Through the mutual practice of speaking and listening, the C-R groups gave these experiences value.

Nick: And of course that still goes on today, and so fundamental writers like Irigaray who really questioned the conditions under which voices are produced are important. At the time she was really asking the deepest questions about the conditions under which we speak and care for others, so I've always been interested in her work. This question of recognition is really important and that of course implies that in any collective or any situation where you're trying to build a practice, you have to think seriously about what it is to recognise each other effectively and what it is to pretend to do that. Recognition is not a negotiable value, you can't just do it some of the time, it has to be all the way through at all times. It is obviously linked to feminist values of care and so on. Honneth is very much influenced by feminism.

Lucia: We might also think about precarity, the way in which it effects people across different sectors. Groups such as PWB have forged new solidarities where there hadn't necessarily been any connections before. It would be helpful to hear what PWB thinks about the relationship

between listening and solidarity.

Alex (PWB): This is the force of listening, because if you take time to listen, it creates solidarity... This is how collectives are set up, by showing solidarity and caring: by really listening and trying to understand the position of somebody else.

Amy (PWB): I think this is a useful point for us because we have created solidarity projects like the Anti-Raids Network (a London-based network of people that resist immigration checks).

Lucia: Does solidarity in this case mean to *listen with* rather than *listening to*? How might it work?

Mila (PWB): I think we all occupy different positions, for example I am a migrant, I am an artist, I am a cultural worker, I am not in the place of just one position..., but as a group we recognise that precarity is not just in the cultural sector... we are articulating a non self-focused group, so it is not just about cultural workers not being paid, but also about a wider scenario of exploitation, like people that don't get a visa and who can be exploited in the work place.

Lucia: So, is it about recognising the other's conditions?

Chloe (PWB): Yes, but also you literally stand with someone or with the group, for example we were with the cleaners on the picket line... This act of standing is an act of solidarity.

Mila (PWB): I remember once we called for a strike with the teachers and there has been discussions about artists being on strike and whether anyone would care about that. Artists being on strike in solidarity with others – it does not make any sense! It is weird, because I can just say I don't turn up in my studio to strike! [General laughter!]. But in

theory this could work in terms of solidarity.

Martha (PWB): I don't think we can talk about solidarity in the plural, because for me it is a social justice project, there is so much to be done and I cannot do it all...

Amy (PWB): I can tell of an episode with a student of mine who asked me about assessing things after the student protests, as he thought they had failed. I said to him that they did not fail because the students actually learnt how to speak to each other in a big group, how to speak to the media and to organise themselves and, for example, making a banner or learning how to run a consensus decision meeting and all of that kind of stuff that normally happens outside of academia and the art world.

Lola (PWB): Talking about failure, I was reading the account by Robert Lumley about the crises of Italian social movements after 1978[3]. It has been described as *riflusso* (flowing back, ebb), a tide that had turned, a historic phase that was over, but also as a growing sense of failure in the groups of the New Left who believed in collective mobilization. Lumley pointed out that while the feminist project suffered from the crises, it was not itself the centre of that crisis because it always had a certain distance from dominant forms of oppositional politics (which were the main victims) and their authoritarianism. So while all the social movements went into decline after 1978, the women's movement did not so much collapse as change its forms. Instead of seeking recognition from the institutions and the political parties women kept doing things, they organised independent women's health centres, they joined the ecology and peace movements, they established women's libraries, etc.

Martha (PWB): We have to be careful to say that femi-

nists are working differently because there are hierarchies there as well…

Chloe (PWB): Yes, but I guess the point is that the feminist project (particularly in the second wave in the 1970s) aimed to work against hierarchy even if it was not totally successful.

Martha (PWB): To go back to the issue of listening, who is listening and when the right time is for listening is very important. I absolutely take the point that it is not just simply recuperating failure or insisting on other ways to succeed. Some of them are really unexpected, we can only recognise them in retrospect… I was thinking the other day: is there any institution of art that fails? It seems to me that they always succeed, because from websites etc. it all seems so self-congratulatory.

[Laughter!]

Mila (PWB): This is a great project on failure [laughter!]; actually there is already a book on failure at the Whitechapel!

Lola (PWB): Yes, it has become a new artistic trope!

Martha (PWB): Interestingly enough, recently at the London art college where I work, we have all these staff meetings and one time the head of something important, came to the auditorium and said "I am here to listen", "you can tell me anything".

[Laughter!]

Alex (PWB): In the auditorium, on stage?

Martha (PWB): Yeah, it was absolutely preposterous!

Chloe (PWB): And everybody was silent right!

Mila (PWB): Like somebody with a shopping list who pretends to listen…

Chloe (PWB): And it is interesting that he didn't understand that the space is not created by saying "I am here listening"!

Martha (PWB): Yes, always when you get people like managers that are doing their best it can be so rude because they are not really listening…
Something that we talked a lot about at the art college is the fact the people are so over-managed that they are paralysed, so they can't actually take action, they can't even ask anything because nobody is listening. So it is extraordinarly complex and for me the idea of listening as labour is really crucial, because I mean, I feel very exhausted after listening carefully to something. I need time and I need to plan you know! It is really hard work!

Lucia: So what I am hearing here from PWB is this idea that listening is labour and the way this is managed or organised can provoke different kinds of answers or no answer at all, if we take this example from Martha about the manager saying "I am here to listen"!

Claudia: In terms of recognition, to really listen to someone, means to recognise his or her value. In hierarchical or top down power structures, there is often a struggle for recognition from those in positions of power by those that are subjugated, marginalised or not listened to.

Lucia: This is an observation that can be applied to many different contexts. In regards to art and politics Boris Groys once wrote that: "art and politics are connected in one fun-

damental respect: both are realms in which a struggle for recognition is being waged"[4]. According to Groys, artists of the historical avant-garde contended for recognition of individual forms and artistic procedures that were not previously considered legitimate. Nowadays this "protest for aesthetic equality" is no longer part of the struggle because, as Groys argues, the contemporary neo-liberal media markets have eliminated any conflictual space between artists and art institutions. The original struggle of the avant-garde against the museum as the space of true art is today replaced with an induced desire of stabilizing and entrenching prevailing tastes.

Claudia: So this was the struggle for particular art forms to be recognised as legitimate by the establishment. This kind of struggle or demand for recognition seems to be directed towards what an institution or establishment considers as valid or valuable. This is a different kind of recognition than solidarity that makes me think about Rancière and his ideas of the "distribution of the sensible". I don't agree with a lot of what he writes but his characterising of the space of politics as a struggle for recognition of the unheard and unseen, the voices that are not characterised as political, can be very useful particularly when thinking about the recent square movements for example.

Lucia: Seeking recognition from an institution does imply some kind of hierarchical structure according to which who is at the top of the institution is the most successful and recognised person. This form of recognition is functional to the paradigm of success promoted by dominant power structures and their ethos on competition, individualism and talent as a winning force (e.g. patriarchal structures, the neoliberal market). What has started to emerge through this discussion is instead a more horizontal structure of recognition which goes beyond this dichotomy of success

and failure. This is linked to the possibility of creating new forms of mutuality by giving more time to listening.

Claudia: I think that solidarity can be understood at its most basic level as a form of mutuality, *listening with* as well as *listening to*. If we think about how feminist consciousness-raising groups operated, the things women said about their own experiences *resonated* with others. Something was recognised in what someone else said as mutual, as something more than just on an individual level. This resonance seemed to go alongside the recognition of individuals as part of the group and society, in helping them to realise the shared conditions and empowering them to change things either separately, in their own lives or together in political campaigns and actions. It's perhaps a cliché, but solidarity can create a feeling of strength that is more likely to lead to action.

Lucia: Feminist and art critic Carla Lonzi uses the term resonance to describe her experience of *autocoscienza*. In her diary written in the early 70s, she compared her previous experience of talking to artists with the gathering and the interpersonal exchanges she had with the women of Rivolta Femminile[5] (Female Revolt). She felt, when she was active as an art critique that the self-realisation of the artist often implied the other purely as spectator, while feminist consciousness-raising was for her a process of mutual recognition through which the subject is realized. She writes:

"… the recognition, which gives birth to the subject while expressing another subject which can subsequently be recognised, is the operation that brought my process to the goal of *autocòscienza*."[6]

The process of recognition involves the reciprocity of listening and speaking and it is the result of this mutual exchange. Radically different from the politics of specta-

torship that operates within the arts, the practice of *auto-coscienza* was instead a participatory space through which women manifest and recognise each other.

Claudia: It's interesting to think about that difference.

Lucia: Yes, the distinction between the politics of resonance of *autocoscienza* and the politics of spectatorship of art, was already present in the writing by Rivolta Femminile as part of a critique of "male patriarchal creativity" or what was seen as the tendency to reduce women both to objects and spectators[7].

I am fascinated by Lonzi's work because her way of deconstructing "a male patriarchal creativity" gradually developed into a dialogic and a relational mode of writing which can be considered an ongoing process of undoing. This began by questioning art theory and criticism as an exhaustive form of intellectual practice. It gradually developed into feminist collective texts and finally became a deeply personal and intimate form of writing. I see her whole writing project as a creative and political act of listening through which she orchestrated the many voices that populated her life, including her own poetic voice[8]. It was this aspect of her work that partly inspired this project as a piece of dialogic writing[9].

Claudia: Resonance is also of course a term very much connected to sound…

Lucia: It is indeed! In the case of Lonzi this term also connects to the use of the tape recorder as a fundamental instrument for her work. From an early book such as *Autoritratto* (Self-portrait, 1969), to her last work, *Vai Pure* (Now you can go, 1980) resonance is a term that can be applied to her work in two ways, as a metaphor of recognition of the self through the other, but also as a sonic device through

which she constructed her written dialogues.

Claudia: What do you think the importance of the sonic is in relation to the practices we have been discussing?

Lucia: I think it is the singularity that is expressed, contained, embodied in a voice that communicates to another voice. The people's tribunal by the Precarious Workers Brigade (we talked about this in *Collective listening*) provides a good example of how a story can be physically carried or channelled through by the mouth of somebody else and still be a very effective and powerful action. By reading out in public many of the testimonies given by several different people, PWB generated a very lively debate but also a truly relational, and emotional space. *Vocality* (the term used by Cavarero) in this context was important not in terms of retaining the authentic sound of the voice of the people who gave testimony, but in order to produce that quality or level of interaction between people. While the anonymity was important to protect the vulnerable people present in the room, the storytelling creates an incredible emotional response. So there is the issue of affect carried by and generated through the sound of the voice, how its colour, grain, modulation creates empathy or some kind of awareness in the listener.

Claudia: Is it the vocal embodied that makes this so powerful for you?

Lucia: Embodiment is certainly important. And this is an issue that has been extensively debated within a feminist tradition, in particular between Judith Butler and Adriana Cavarero. If we embrace Cavarero's perspective on embodiment, voice is the cipher of "embodied uniqueness". The human voice is not however pure sound, as the body is not pure flesh, impersonal and irrational.

As Adriana Cavarero suggested in her work *Relating Narratives*, "what makes a narration a political act is not simply that this narration invokes the struggle of a collective subjectivity, but rather it makes clear the fragility of the unique"[10].

To start from the question "who are you?" rather than, "what are you?" was a way for women in C-R groups to recognise each other through solidarity and empathy, and also a way to listen to their own internal contradictions.

Claudia: I can see that both in the context of C-R groups and the more performative space of the PWB tribunal, the physicality of the narration was important. By voicing into the space experiences that resonate with others, solidarity was created between participants. A shared sense of value and one that might be then used to challenge social structures and attitudes.

Lucia: Robert from Ultra-red also talked about the people in Appalachia who recognised their values by listening to their own contradictions.

I think another issue that is important in the process of recognition and was also mentioned by Robert and Janna – as well as Nick who talked about it earlier in relation to Honneth – is that of care. The care of the body is of course a very central issues of social reproduction and the feminist critique of labour, yet it remains an overlooked issue in contemporary society.

Claudia: For political theorist Susan Bickford "political listening is not primarily a caring or amicable practice"[11]. She emphasises this precisely because listening tends to evoke ideas of empathy and compassion. This sounds quite harsh, but I think it is interesting because it is so different from what we are used to hearing. She takes the emphasis off the desire for complete consensus. She sees the space

of politics even in democratic societies as a conflictual and contentious one. Therefore a very particular kind of listening is required, one not based on care or friendship. Addressing a conflict through political interaction demands that we resist the desire for complete control.

Lucia: What you are posing is a very burning issue as it is never easy to speak about conflict.

Claudia: No, but you can't have everybody always agreeing all of the time. There might be affect that is generated by listening but it might not always be empathetic. What happens when we get into a space of disagreement or even antagonism? I think she raises some interesting questions including about what happens once you get beyond a group that knows or trusts each other. These ideas are based on an agonistic model of democracy, that is, one that allows space for disagreement and conflict. In fact, Bickford draws from Hannah Arendt on this.

Lucia: Doesn't Arendt's idea of politics as a space of plurality precisely allow for difference?

Claudia: Yes, exactly. Interestingly in political theory, agonistic models of democracy and deliberative models of democracy, that is, the idea of coming to consensus through a process of deliberation, are generally positioned as opposites[12].

Lucia: But what might be the problems with consensus?

Claudia: An expectation of complete consensus and agreement can be fascist in its own way. This is a force of listening that we don't want, right? I will listen to you until you agree with me. Bickford argues that it is exactly the presence of conflict and difference that makes communicative interaction necessary. Politics is precisely about the

dynamic between speaking and listening and not listening as an effective kind of power.

Lucia: Does that mean that the possibility of consensus is discarded completely?

Claudia: No, not necessarily. It is possible to allow more complexity than that, there may be ways to allow elements of both. As well as Arendt's ideas of equality and distinction and the notion of human plurality, Bickford looks to Aristotle and the practice of deliberation. The most important thing for her is the quality of attention inherent in the practice of deliberation, the need for attention to others. Interestingly, Bickford uses an example from phenomenology to think about this, using ideas of "figure" and "ground". She raises the concept that listening has often been seen as a self-annulling process that through being open to the other, the self becomes absented. She argues that political listening cannot be grounded in an absence of self. Indeed, politics requires the opposite. She looks to Merleau-Ponty for ideas of relationships of consultation and exchange. "Politics requires self-involvement with others in action, where we do not 'draw back' but actively engage with one another with direction and purpose"[13]. Openness is still required but also agency and situatedness. It is the self as ground and the other focused on as figure. One person's perspective is understood in the light of another's and theirs in the light of mine.

Listening is risky as what we hear might require change from us, and change can be painful. This is where Bickford suggests the image of listening as a journey or bridge to travel on. The journey is a joint effort. The listener must also expect to change as well as those being listened to.

Lucia: So a return to reciprocity…

Claudia: But without an expectation of friendship or consensus on everything. It's a difficult one to think about, but probably necessary. For example, if I think about the housing co-op where I live, we have to somehow work together and listen to each other without necessarily agreeing on everything or being friends. There are people I don't particularly get on well with or want to be friends with, but I have to be able to live in the same building and work with them effectively. We do try to work towards some kind of loose consensus, which is not always possible.. Listening has a part to play in this and I think Bickford raises some interesting questions around how we might go about it.

Lucia: So this is recognising difference as well as value…

Claudia: Yes, exactly, and that recognition of difference and value might create a kind of solidarity that is not necessarily based on complete agreement.

Lucia: Well, the notion of difference is important in the development of Cavarero's idea of a politics of voices, it is in fact informed both by Arendt's idea of a political sphere and an Italian feminist take on sexual difference. As I understand it, this notion of difference is predicated on a relational space created by reciprocal communication of women in flesh and bone. Cavarero argues that the political quality of this communication is not determined by the feminine sex "rather, this politics consists in the relational context or, better, the absolute local where reciprocal speech signifies the sexed uniqueness of each speaker in spite of patriarchal prohibitions"[14].

Claudia: How is a relational space produced?

Lucia: In terms of the sonic experience, a relational space is not simply created through sound, but through affect

and resonance. And when acoustic resonance is produced by the human voice, it could be further argued, that resonance is the embodied quality of listening. The vibrational, "resonant subject is never purely self-referential, is not me, neither the other, but always the result of resonance itself"[15]. So a way of rethinking politics through "embodied uniqueness" is to imagine a scene "where in any part of the globe, some human being actively and reciprocally communicates their uniqueness and shows this uniqueness as the material given that constitutes the contextuality of their relation"[16]. This is what Cavarero calls the "absolute local" and defines it in terms of "spatiality in action". As she said and explained earlier (in Chapter 3: *Towards a Politics of Voices*): "the absolute local of the political, means to act directly one in front of the other on a horizontal level". Cavarero pictures this process of interaction in the absolute local as a kind of song: "Like a kind of song 'for more than one voice' (*come una specie di canto a più voci*), whose melodic principle is the reciprocal distinction of the unmistakable timbre of each – or better, as if a song of this kind were the ideal dimension, the transcendental principle, of politics."[17]

Claudia: That's very poetic. It's a lovely metaphor for collectivity, but I would also want it somehow to allow for dissonance. We've been talking about the need to allow space for disagreement. If the melody (using the same metaphor) is too harmonious, it's perhaps in danger of becoming the homogenous entity we discussed in *Collective Listening*. That's not to say that resonance cannot occur, in fact as we've discussed earlier in this chapter, the invocation of a corresponding or sympathetic response is really important in order to create solidarity. So perhaps we are looking at an idea of politics that embraces both resonance and dissonance, not based purely on togetherness.

Lucia: Well, dissonance comes from the Latin *dissonare*: to

differ in sound. As we've seen, the whole notion of the shift from speech to voice politics is a way of conceptualising difference.

Claudia: I'm also interested in thinking about the actual spaces that the reciprocal relations we've talked about happen in. C-R groups for example operated in semi-private spaces, in people's homes, or community spaces. The voicing of the self, happened in relative safety. But once you step out into a more public space you might face fears of being wrong. Certainly there was more at stake in speaking at the people's tribunal at the ICA, this was one of the reasons members of PWB didn't speak their own stories... Susan Bickford writes about the need to develop a sense of carefulness in this context. That perhaps we don't want to reveal ourselves too much and that we are unable to control the result. She asks how listening can be made visible or audible; how can it appear in public?

Lucia: I think it depends on the context... I remember being really excited when I was spending a lot of time at London Occupy, I mean actively involved in the assembly that was happening every day in the square at St Paul's Cathedral... Somehow listening in that context became very visible through some of the protocols and techniques that people of Occupy used there.

Claudia: At Occupy there were practices very much based around consensus as a decision making process. There was also a resurgence of ideas of direct democracy generated by new social movements that emerged during 2010/11 that came out of a certain disillusionment with representative democracy. Occupy responded in a particular way to ideas of relationality, physical space and the proximity of direct democracy.

Lucia: Yes, and this happened again in a physical space, in the square, as if any idea of direct democracy is always connected back to the agora, the public space of the *polis*. Where Arendt's thought becomes useful, I think, is when that idea of the public sphere is not anchored to a physically situated territory. The *polis* is not a nation, nor a fatherland, nor a land, it is instead, as Cavarero puts it, "a relational space that is opened by the reciprocal communication of those present through words and deeds"[18]. This relational, shared space was completely realized by C-R groups, in allowing women to create a context in which to exhibit *who* they were to one another.

According to Cavarero, the typical feminine impulse to self-narration finds in the practice of consciousness-raising a political scene that corresponds to the interactive political space theorised by Arendt. Occupy's strategies instead relied on ways of speaking and listening quite different from the intimate space of storytelling. As we will see in the next chapter the Occupy movement was much more preoccupied to create a political scene in which diverse voices were heard louder and louder. This somehow compromised the possibility of developing the square movement into a relational space of a longer and perhaps wider scale (and this is perhaps a significant difference between the temporal relational space of Occupy and the long term relationships established between women within and after the movement in the 70s).

Chapter 8: Occupy

This chapter is dedicated to the Occupy movement for two reasons. For many of our interlocutors, Occupy represented a key reference point in terms of creating an alternative political space. It also resulted in something of a re-invigoration of dialogue as a fundamental part of a wider movement for direct democracy. And while it has been several years now, Occupy also represented a very pivotal moment for us personally. The desire to co-write this book can be traced back to our common experience of taking part in the three workshops organised by PWB at Occupy London. Listening to other's experiences of precarity, as well as our own, represented a key moment for us to reflect on what listening can do. Here we discuss some of the dialogic practices and protocols used at Occupy, including "the People's Microphone" and consensus decision making. We discuss the contribution that feminism and especially the processes developed during consciousness-raising groups have been to these deliberative procedures. As well as it being a very positive and pivotal experience, challenges and tensions also emerged during Occupy, some of which were familiar and some less so. How to deal for example with knowledge from older generations of struggles, how to deal with unseen power structures, race and gender, internal divisions, celebrity speakers and the lack of designated spokespeople, or with the tensions between operative and non-operative speech. When action becomes imperative what happens to speech and listening? What temporal considerations need to be taken into account? The ethics and politics of speaking and listening at Occupy had their own particular configurations. While we do not want to fetishize or romanticise Occupy's protocols, those politics and ethics of listening may offer a learning lesson for future configurations.

The montage for this conversation includes the voices of Ayreen Anastas and Rene Gabri, Pat Caplan, Nick

Couldry, members of the Precarious Workers Brigade (PWB) and Janna Graham and Robert Sember of Ultra-red (UR).

Lucia: In November 2011, I was asked to write an article on Occupy London for a new online magazine called Doppio Zero[1]. I was very excited about this invitation as I was getting a bit tired and frustrated about writing about art. I remember that I spent hours and hours on the steps of St Paul's by myself, observing the people talking to each other. With some initial trepidation, I joined them as I wanted to understand better those protocols used by Occupy. Suddenly I realized that I was totally immersed in the assembly. How do you call this? [makes jazz hands]

Janna (UR): Jazz hands [Laughter!]

Lucia: This is a fantastic device. It's feedback while listening.

Janna (UR): Its part of consensus decision making and is actually from deaf culture.

Claudia: These waving hands were so indicative of Occupy for a while, as well as for many of the occupations that sprang up in response to austerity and the cuts. It could be seen as an example of voice that operates as both speaking and listening – embodied but not reliant on sound. And because it is not sonic you can indicate agreement with something while someone is still talking and still be listening.

Robert (UR): It's been around for a very long time. These literacies exist. This is what's so extraordinary, people know so much.

Lucia: For me it was actually the first time that I had experienced that. In that moment I thought that there was a very elementary way to feel active and be part of the protest:

to act by listening! I also thought (and I am still thinking) that the courage, the determination and the desire to act, relies very much on the ability of listening and thinking together with other people. I pictured that moment as a scene of collective listening but also as a matrix of common intelligence, an intelligence which has been neglected by the individualism and careerism of neoliberalism, and also impoverished by social media. Maybe I have made too much out of that moment; however I found it extremely energising to be at Occupy and meet new friends through the people from the Precarious Workers Brigade who felt the urge to speak about precarity and exploitation in the cultural sector. So speaking out was for me equally important.

Claudia: I had been involved in a peer co-counselling organisation for a number of years and it is through that experience that I had really seen how listening can be a very transformative action. As well as listening together in pairs, we used to do listening projects in public spaces. I remember going to an antiracism festival and asking people the question: how has racism affected your life? It was very obvious to me that being listened to and listening to difficult topics, really gave people the opportunity to reflect on themselves and their lives. I was very excited when I saw parallels with this way of working in other practices and in particular in what groups like PWB had been doing at the ICA and at Occupy.

Lucia: The workshops organised by the Precarious Workers Brigade at Occupy London were a great source of inspiration for us. That moments of listening to and with others, I mean with new friends but also unknown people, it felt a very empowering action.

Claudia: Occupy is an important reference point for nearly everyone we've spoken to. Perhaps we should start this

conversation by asking: what were the politics of listening and speaking that arose there? How were they developed and what might we learn?

Rene: I think listening was a really big challenge in the context of Occupy because it created a situation where people were able to meet one another and speak to each other… There was a lot of interesting spaces of sociality and of course the General Assembly… We did an interview before the occupation of Zucotti Park with some of the people involved in Syntagma Square in Athens. They were talking about this kind of liberation of people just speaking, but also about the use of this "microphone". So you had people who for the first time could say what was on their mind and be heard and that was an important part of it.

Claudia: This was in the run up to Occupy Wall Street (OWS). It came out of the growing direct democracy movements over the last few years, particularly the indignados (Los Indignados) in Spain. There was a general disillusionment with representative democracy with many people being "tired of demonstrations that finish happily and then: nothing"[2]. The *Los Indignados* movement rejected the principle of representation and while at first they targeted unemployment and mortgage reforms, "the main message was not about the economic crisis but about the breakdown of political accountability and representation"[3]. Demanding direct deliberative democracy in which citizens could debate issues and seek solutions in the absence of representatives.

OWS followed the indignados model of general assemblies and break out working groups in an attempt to practice more horizontal forms of organisation. The activist community that took place began to take organisational forms that embodied the kind of society they wished to create, in particular more horizontal rather than top-down hierarchical structures, non-hierarchical forms of democracy.

This is what's known as "pre-figurative politics": that is, creating the society you want within the existing one. Generally in these movements, representatives of organised political groups like political parties are excluded. Rather than trying to work out what a detailed architecture of a free society might look like in the future, they try to create the conditions that enable people to find out along the way.

Robert (UR): One of the most amazing things about Occupy was all of the elders who were there in the beginning quietly sharing their deep knowledge about organising. There was a period where they withdrew for various reasons, and the younger activists were at a loss at how to address what was actually the crisis that was inevitable within the movement, which was its internal divisions and conflicts. In New York it became completely predictably about gender and race again, and about not being heard. You had women of colour saying "we are not being heard", "we are not being heard", "we are not being heard". And what was the response from the movement? It was irritation. We have heard you, now let's move on. So that became a question of what it means to be heard. It's not just "I have stopped for a moment to listen to you". Hearing is actually love, to perform that kind of affective action of love. There wasn't a capacity to really do that, and Occupy just amplified and amplified itself. It was very painful to sit in on those later meetings and to see this rupture, and see people not knowing how to act. There is the notion that you have to resolve the rupture, you have to heal the rupture before you can move forward, and in fact it's an impossibility. You have to embrace the crisis and move through in a much slower way.

Rene: Processes were created where supposedly everyone would be able to speak and be heard, but sometimes these processes also created a certain kind of way of speaking and

listening basically orientated towards action. And maybe this occluded listening because sometimes there wasn't a lot of space for really listening to what people were saying because speech had to be operative. So I found myself often with an ambivalent feeling, not having a clear direction, but I definitely felt that was a very rich experience. Listening takes time, so there is that other dimension that I think is also really important and not understanding that, can be a kind of limitation of our political imaginary. I think that this question of the lack of time that people really afford to listen to one another is important, but afford is probably a stupid word...

Claudia: But it's an interesting word... it makes me think about value.

Rene: There were moments where people could listen to each other, but there were also a lot of frustrations because there were tensions between this kind of operative speech and this non-operative speech that people also need. I felt that it was more the masculine, the more white ethos that won out.

Claudia: In regards to the protocols that were developed at Occupy, David Graeber looks at the evolution of consensus decision making from its beginnings in the radicalism in the 1960s to a more Quaker and feminist inspired consensus. He writes that much of the initiative for creating new forms of democratic processes like consensus emerged from the tradition of feminism, "which means (among other things) the intellectual tradition of those who have, historically, tended not to be vested with the power of command."[4] Consensus as an attempt to create politics founded on principles of genuine deliberation, requires "the ability to listen well enough to understand perspectives that are fundamentally different from one's own, and

then try to find pragmatic common ground without attempting to convert one's interlocutors completely to one's own perspective"[5]. Interestingly, he argues that at some point within the history of consensus decision making, a "desperately needed feminist emphasis on mutual listening, respect, and non-violent communication began shading into a distinctly upper-middle-class cocktail party style emphasis on politeness and euphemism, one of avoiding any open display of uncomfortable emotions at all – which is in its own way just as oppressive as the old macho style"[6] and that conflict and disagreement are actually important for consensus decision-making.

Rene: It's not ironic that the biggest conversation of listening came around Occupy in the nine days that we organized just after the eviction in January, which was called *Crisis of Everything*[7], and was about Occupy from a feminist perspective. We were thinking about the next steps to take and also trying to digest what we had all gone through together. We organized different discussions on different times and days.

Claudia: What's your perspective on Occupy, Nick?

Nick: Occupy took political action into a spectacular centre where it could be seen. It took people and said: spend a few hours of your everyday life living as if you were part of this permanent protest. You don't have to stay there overnight if that's impossible because you've got kids or whatever you have to do. It's not like you can't give it all up, but just imagine that way of living. So it broke down some of the barriers between normal political action and everyday life, and that is the root of anti-politics. We have to do things to survive, interlocking things to survive with each other in contemporary societies where we can't make our own food. Therefore the problem you raised earlier about how

to sustain art practices is a deep one because a wonderful moment in a gallery can be lost on the bus ride back to the rented accommodation… And how do you break that (how do you create institutions?) it's a really big problem. As I said earlier [Chapter 5: *Institutional Frameworks*], you need a certain space "as if" where you can bracket and recognise those important differences for the purpose of imagining a common future.

Lucia: Yeah, but the biggest problem if we are talking about the bracketed space of an art context is the risk to be co-opted or simply aestheticised. I am thinking of that example of the Berlin Biennale we talked about in *Institutional Frameworks*. The relocation of the Occupy camp within that space didn't obviously work in terms of creating a public arena for debate as it was immediately aestheticized. As Michel de Certeau said, space is always a practiced place. So it is always through practice that you produce social space and not simply by displaying a protest camp within an art gallery or a Biennale.

Claudia: But as Nick Couldry also said, Occupy itself, as it existed in the street (not in the Biennale), also acted as a bracketed space in its own right with people practicing different ways of being and doing.

Lucia: Yes, I understand that political intelligence also develops from imagination. Art is not the sole terrain for imagining and creating new scenarios.

Rene: I remember after the occupation there was a complete rejection of certain modes of speech-making like panel discussions and things like that, which was almost sometimes juvenile or reactionary. At 16 Beaver, we have had a long history of organizing talks, so in that nine day period many of the discussions were just open and we also

invited some friends to just give talks... But some people were so resistant to that at the time. I was frustrated because I felt like we needed to have that space of listening too! I think we don't sufficiently experiment with processes of having public meetings or assembling together, listening to one another, you know, and to use the common intelligence in a room rather than always having these long over-programmed conferences which can drive us crazy. Even though we sometimes take part in them, how we can produce such inertness of the bodies in that room, remains an open question. So back to the issue of the listening, there is the importance of the reciprocity, I don't know if that's the right word to choose, but... the necessity of translating that movement from the listening and the speaking to the sensing, to broadening the field of what one can do with that...

Lucia: It would be interesting to hear about the experience of the Precarious Workers Brigade. As far as I remember your workshops at Occupy London seemed to bring together very different people...

Lola (PWB): At Occupy London, we decided to have three workshops. The first one was in the square of St Paul's Cathedral, on the pavement – it was freezing cold! This workshop was completely open. We started with the questions: what is work and what is precarity? Regardless of the weather conditions, people started to gather around the group and talk. It was not so intimidating. It was very much the process of going around the group and asking each person about their experiences. As I mentioned earlier when talking about practices of listening [Chapter 1: *Practices of Listening*] there were different levels of narration as we felt gradually encouraged to say more about our living and working conditions after listening to other's person's stories. The composition of the groups also changed as we changed locations. The second workshop was held at the

University Tent and the third one at The Bank of Ideas.

Mila (PWB): It was very moving. There were people that we were not meeting so often. I remember there was a guy working for Tesco delivering, doing contracting work. At the strike I also remember Tony Benn going around to listen with a van. I don't want to make a rosy picture out of that, but it seems that politicians don't do that much. I am also thinking about Bosnia now, about all those assemblies where people were talking and listening and those cathartic moments. For me, it was quite difficult to listen to all of them because it was so intense. There had been a war. So I could not listen to this for long time, I had to tune in and out. As we were discussing earlier when we were talking about listening as care and affective labour, when you listen you take it in and this is somehow linked to a kind of co-counselling, to therapy and politics.

Lucia: Yes, of course. The workshop of PWB at Occupy seemed very much organised around the task of mapping different levels of precarity, not only in the cultural sector. This made self-employed people like myself as well as the guy working for Tesco delivering, aware of that cross-over. I remember there was also one session with people from the union UNITE who talked about political organising. Because the diverse levels of precarity were emerging step by step around the group, it seemed premature to think how to organise those precarious people in any kind of official union. I can see now that speaking out and listening to each other was like a kind of political therapy as practiced in C-R.
 I know that Pat, one of the women we discussed C-R with was also involved to some extent with Occupy. Perhaps Pat, you might want to say something more.

Pat: I spent a lot of time with Occupy London. I was involved with a library that was occupied, in the borough of

Barnet. I worked with them. What happened was we had to negotiate with Occupy about them leaving the building because Barnet agreed to give the library back to the community. There were endless meetings and somehow it was like going back to the 1970s. The Occupy people had been in that library for 5 months before I came along – protocols is a good word here – they had their protocols about how to run meetings... The contentious thing about that debate was around how democratic it was, there were leaders there, and it was really dangerous because they created a kind of dependency and people turned to them. There was a tension, as it was the kind of environment where people were on the surface trying to create a space for every voice to be heard. It was a hard decision for me because I do not think that libraries should be run by volunteers, they should be run as public services. Working for this library as a volunteer was a huge amount of work and it was clear that the majority of people wanted to keep this space as a library. But then there were also the radical people who thought that choice was a sell-out. I tried to explain to them that we had to make a difficult decision, we needed to go with the flow: that we were not selling out. I did a lot of thinking about this situation of groups within groups as there were very different groups with different opinions and, of course, I came in to this too late. It made me think about what was going on in the left, a very fragmenting situation, not that the feminist groups did not face that...

Claudia: It's easy to see how even if you are striving for consensus there can be difficulties with tacit or hidden leadership appearing within consensus processes. If you operate consensus without any rules, then a tacit leadership will most likely emerge. Jo Freeman pointed this out in *The Tyranny of Structurelessness*. Consensus processes have been adapted to try to address this problem. For example facilitators don't bring any proposals of their own, they are

just there to listen and become the medium through which the group can think and often rotates to allow a gender balance. Many protocols exist partly because of this reason. Decisions are tried to be made at the smaller scale and lowest level possible, in meetings where a spokesperson from each working group takes place for example, and no one can speak for the same group twice in a row.

Lucia: Perhaps problems are more likely to happen when people only know some of the protocols but not why or how they have been developed.

Claudia: There are also other speaking and listening devices at Occupy worth talking about, for example the website that emerged. *We Are the 99 Percent* was set up to allow people to post pictures of themselves, holding up a brief account of their life situations, sharing their testimonies. This was hugely popular with hundreds of people varying in race, age, gender. This is exactly an example of "giving an account of oneself" and also links to testimonies taken by PWB. These accounts and stories of the real stuff of people's lives are the thing that is missing from much mainstream political discourse.

Lucia: As Rene ways saying about Occupy Wall Street, another device used was the people's microphone. This was developed as a response to restrictions, out of the fact that amplified sound required a permit in New York City, and that this had been repeatedly denied to OWS. The human microphone was a solution that circumvented these restrictions and simply functioned with people of the crowd amplifying their voice of whoever was speaking. There was something particularly special about this and even in places where amplification was allowed such as at St Paul's in London, the people's microphone was still used as a way of constituting the listening public.

Claudia: Sarah Van Gelder who edited a collection of reports and essays about Occupy wrote that the people's microphone encouraged "a deeper kind of listening" because audience members had to actively repeat the language of the speaker. She suggested that it actually encouraged consensus "because hearing oneself repeat a point of view one doesn't agree with" was "a way of opening one's mind"[8].

Lucia: There is perhaps something symbolic about direct democracy and Occupy's protocols. However, it is important not to fetishize the people's microphone *per se*. When celebrities started to arrive at the camp to show their support, everyone was glad to see them, yet this prevented a truly process of collective discussions as the old speech mode, or the speechifying, became infectious.

Robert (UR): Exactly. Benjamin talks about the notion of the ideological patron, or the intellectual patron. This is what happened at Occupy in New York. Suddenly it became the focus of great excitement and then you had all of these intellectual patrons, who are great people.

Janna (UR): Not all of them. [Laughter!]

Robert (UR): But they would parade through and have their moment. And lingering to this day, for most people who were very involved with Occupy, is a great deal of anger about the fact that people were allowed to jump stack. If you were Žižek and you arrived down at Occupy you jumped stack. You got to say your thing and then you left. The most fundamental condition of Occupy was listening and you did not participate in that. You spoke, but you didn't listen. That's the condition of the intellectual patron. And in that sense it simply re-inscribed a certain convention around the political.

Claudia: This was something that also happened to some extent in the women's movement. Jo Freeman writes about the "star system" that emerged even though they were trying to work against hierarchy. The women's movement had not used any of the usual techniques (votes, surveys or selected spokespeople) to communicate with the public but the public was conditioned to look for spokespeople. The press and public expects political groups to select people to articulate their decisions. The women's movement did not consciously choose any spokespeople but many of them caught the public eye for various reasons and because there were no official spokespeople, nor any decision-making body, the press could interview those particular women who were perceived as the spokespeople whether they wanted to be or not. Occupy was similarly criticised for its lack of spokespeople. But there is the argument that the Occupy movement was precisely about the opening up of radical imagination, that democracy was considered as a kind of collective problem solving.

Lucia: Can this radical imagination be connected to what Cavarero's conceptualized as the "absolute local"? An idea of democracy that is not bound to a national state, to a territory but to poly-vocality and again Arendt's notion of action.

Claudia: Well it is certainly one way to theorise it…

Lucia: If we take this idea of politics, then the Occupy movement could be seen, at least in principle, a good example of participatory democracy which valued both voice and listening. But in reality, Occupy also failed to sustain a plurality of voices in the moment which certain protocols started to crack up. So the issue of how to recognise uniqueness within plurality, and not falling back into the trap of "celebrity politics" seems a quite big challenge for the future… Perhaps Nick, you want to add something here?

Nick: Well, to put it crudely: Occupy was very effective for a while. Because it worked, it was quickly replicated in re-hearsing the general will – talking and thinking together about the big problem that no one had the answers to, do-ing it together, accountably and publicly. At that time, the general will did not exist anymore, but some people refused that and said let's try again, let's try differently. I don't know about you, but I was quite interested in the political move-ment of Transition towns, which was organized around the concept of "peak oil". The Transition movement said ok we want to do politics, but we don't want to do it in the normal way, we are not going to have an elite, we are just going to go into a situation and ask people a simple question – how will you survive if food can't be brought to you by lorries and whatever? How will you solve that problem? You and your group of people are here right now, you are going to have no choice but to solve it together, unless you walk away. How will you start to think about that and allow people to start to self-educate in order to try and solve a problem that they didn't originally think was political? They quickly realised that to think about survival through collective resources was deeply political and that really interested me because it's a way of mutual re-education on the way to politics. It wasn't directly politics, it didn't care about the state. It was nothing to do with the state, not to say that they didn't want the state to listen, as they did. Now I think Transition has become nor-malised, banalised. I found out that Chiswick, where I live, became a transition town and I never even knew about it. I saw a posted at the riverside, and that was something no-one had told me, it somehow disappeared but the idea was an incredibly strong one.

Claudia: Yes, I found transition towns interesting too be-cause there seemed to be a network that was starting to be created that transcended national boundaries and govern-ments. Instead, transition towns were linking up and talk-

ing to each other. It's a shame how that somehow subsided. I don't know if the timing had anything to do with the financial crisis, if the necessity of bare survival took over, but it disappeared at about the same time. It is interesting to think about the temporality of these movements, how they ebb and flow, develop and fade.

Lucia: Perhaps we can end our conversation by going back to Hannah Arendt. She said that people interacting together can create a potential political space, and the word "potential" (from Latin *potentia*, force, power), seems very crucial in what we have tried to map out through this conversation. She wrote:

"Wherever people gather together, it is potentially there, but only potentially, not necessarily and not forever."[9]

Notes

Introduction

1. Christoph Cox and Daniel Warner, ed. by, *Audio Culture. Readings in Modern Music* (New York, London: Continuum, 2008); Douglas Kahn, *Noise, Water, Meat. A History of Sound in the Arts* (Cambridge, Mass.: The MIT Press; 2001); Allen S. Weiss, *Breathless. Sound Recording, Disembodiment and the Transformation of Lyrical Nostalgia* (Middletown: Wesleyan University Press, 2002).

2. Brandon LaBelle, *Background Noise. Perspectives on Sound Art* (New York: Continuum, 2006).

3. Seth Kim-Cohen, *In the Blink of an Ear. Toward a non-cochlear sonic art* (New York, London: Continuum, 2009).

4. Angus Carlyle and Cathy Lane, *On Listening* (Uniformbooks 2013).

5. Gayatri Spivak, 'Translator's Preface and Afterword to Mahasweta Devi, "Imaginary Maps"', in *The Spivak Reader*, ed. Donna Landry and Gerald MacLean (New York: Routledge, 1996), 267–8; and Sara Ahmed, *Strange Encounters: Embodied Others in Post-Coloniality* (New York: Routledge, 2000).

6. Susan Bickford, *The Dissonance of Democracy: Listening, Conflict, and Citizenship* (Ithaca, N.Y.: Cornell University Press, 1996).

7. Paulo Freire, *Pedagogy of the Oppressed* (New York, Continuum,1970).

8. Paolo Virno, "Virtuosity and Revolution: The Political Theory of Exodus", trans. by Ed Emery, 1996. Accessed 7 April 2016: http://www.generation-online.org/c/fcmultitude2.html.

9. Adriana Cavarero, *For More Than One Voice: Toward a Philosophy of vocal expression*, translated and with an introduction by Paul A. Kottman (Stanford: Stanford University Press, 2005).

10. Suzi Gablik, "Connective Aesthetics: Art after Individualism", in *Mapping the Terrain – New Genre Public Art*, ed. by Suzanne Lacy (Seattle, Washington: Bay Press, 1995), 74-87.

11. Suely Rolnik, "The Body's Contagious Memory. Lygia Clark's Return to the Museum", trans. by Rodrigo Nunes, 2007. Accessed 7 April 2016: http://eipcp.net/transversal/0507/rolnik/en.

12. Alana Jelinek, *This is Not Art. Activism and Other 'Not-Art'* (London, New York: I.B. Tauris, 2013), 91.

13. Ibid., 5.

14. Nick Couldry, *Why Voice Matters. Culture and Politics after Neo*

Liberalism (London: Sage, 2010).

15. Wendy Brown, "American Nightmare: Neoliberalism, Neconservatism and De-Democratization", *Political Theory*, December 2006, Volume 34, Number 6, 690-714.

16. John Holloway, *Crack Capitalism* (London, New York: Pluto Press, 2010), 77.

17. Ibid., 7.

18. Following De Certeau "space is a practiced place", Michel De Certeau, *The Practice of Everyday Life*, trans. Steven Rendall (Berkeley: University of California Press, 1984), 117.

Interlude....or Prelude

1. Jean-Luc Nancy, *Listening*, trans. by Charlotte Mandell (New York: Fordham University Press, 2007).

2. Roland Barthes, "Listening", in *The Responsibility of Forms: Critical Essays on Music, Art, and Representation*, trans. Richard Howard (New York: Hill and Wang, 1985).

3. Pauline Oliveros, "Quantum Listening: From Practice to Theory (To Practice Practice)", presented at the International Congress Culture and Humanity in the New Millenium: The Future of Human Values. The Chinese University of Hong Kong, January 8, 200, MusicWorks Issue #76 (Spring 2000), 73.

4. Barthes, "Listening", 246.

5. John Holloway, *Crack Capitalism*.

6. Susan Bickford, *The Dissonance of Democracy*.

Chapter 1: Practices of Listening

1. This was the *People's Tribunal on Precarity* that took place at the Institute of Contemporary Art, London in 2010. The collective came out of this event. People's tribunals are forms of tribunal that 'can be applied in work-related situations where systemic injustice, normalized to the point of intractability, lies beyond the reach of existing labour and employment legislation and policy' http://precariousworkersbrigade.tumblr.com.

2. The artist collective e-Xplo was founded by Heimo Lattner, Erin McGonigle and Rene Gabri in 1999. www.e-xplo.net.

Chapter 2: Feminism. Speaking and Listening in Feminist Consciousness Raising Groups

1. Dale Spender, *Man Made Language* (London; Boston: Routledge

& Kegan Paul, 1980), 128

2. http://www.womensliberation.org/.

3. Spender, *Man Made Language*, 93.

4. The Milan Women's Bookstore Collective, *Sexual Difference. A theory of Social-Symbolic Practice* (Bloomington and Indianapolis: Indiana University Press, 1990).

5. Carol Hanish, "The Personal is the Political", 1970: http://www.carolhanisch.org/CHwritings/PIP.html

6. Kathie Sarachild, *Consciousness-Raising: A Radical Weapon*. Document from the Women's Liberation Movement, Duke University, 1978. Accessed 7 April 2016: httPat://internal.rapereliefshelter.bc.ca/issues/Conciousness-Raising_A_Radical_Weapon.html, 1978

7. Rebecca West, Jane Marcus, *The Young Rebecca: Writings of Rebecca West, 1911-17* (Indiana University Press, 1989).

8. Spender, *Man Made Language*, 121.

9. Ibid.

10. The Milan Women's Bookstore Collective, *Sexual Difference*, 59.

11. See the analysis of Robert Lumley about the so-called riflusso of the late 70s in Italy. Robert Lumley, *State of Emergency. Culture of Revolt in Italy from 1968 to 1978* (Verso, London, New York, 1990).

12. Spender, 124.

13. Carla Lonzi, *Taci anzi parla. Diario di una femminista* (1978) (Milano: et al. Edizioni, 2010) 35, translation by Lucia Farinati. I would like to thanks Francesco Ventrella for introducing me to the work of Carla Lonzi.

Chapter 3: Towards a Politics of Voices

1. Adriana Cavarero's parts included here are excerpts from a recorded interview conducted by Lucia Farinati in collaboration with artist Mikhail Karikis, in Verona, 10 March 2011. The interview has been transcribed from Italian and translated into English by Lucia Farinati for this publication. Our conversation with Nick Couldry was recorded in London in May 2013.

2. Couldry, *Why Voice Matters*, 13.

3. Cavarero, *For More Than One Voice*.

4. Don Ihde, *Listening and Voice, Phenomenologies of Sound* (Albany, NY: State University of New York Press, 2007).

5. Adriana Cavarero, *Relating Narrative: Storytelling and Selfhood* (Warwick Studies in European Philosophy, 2000).

6. Cavarero, *For More Than One Voice*, 13.
7. Hannah Arendt, *The Human Condition* (Chicago: University of Chicago Press, 1958).
8. Bickford, *The Dissonance of Democracy*.
9. Ibid., 69.
10. Ibid., 144.
11. The Milan Women's Bookstore Collective, *Sexual Difference*.
12. See Cavarero, *Relating Narrative* and also Adriana Cavarero and Franco Restaino, ed. by, *Le filosofie femministe* (Milano: Bruno Mondadori, 2002).
13. The Milan Women's Bookstore Collective, *Sexual Difference*, 42.

Chapter 4: Collective Listening or Listening and Collectivity
1. LaBelle, *Background Noise*, xi.
2. See for example the work by Claire Bishop, Miwon Kwon, Suzanne Lacy, Maria Lind, Irit Rogoff.
3. Steve Roden, "Active listening", 2005. Accessed 7 April 2016: http://www.inbetweennoise.com/texts/active-listening/.
4. Salomé Voegelin, *Listening to Noise and Silence: Towards A Philosophy Of Sound Art* (New York, Continuum, 2010).
5. Theodor Adorno, "Composing for the Films"(1947), in Cox and Warner, *Audio Culture*, 74.
6. Mladen Dolar, *A Voice and Nothing More* (Cambridge, Mass.: The MIT Press, 2006).
7. The nanopolitics group formed in London in early 2010, around a desire to think politics through and as embodied experience and practice. They have organised open movement, theatre and body-work based workshops, as well as discussions and interventions in the context of social movements. For a reflection on listening and speaking warm up exercise see Anja Kanngieser, "Toward a careful listening", in *Nanopolitics handbook* ed. by Paolo Plotegher, Manuela Zechner, Rübner Hansen (New York, Port Watson, Wivenhoe: Minor Composition, 2013), 235.
8. Sisterhood and After oral history project held at the British Library Sound archive.
9. This project consists of a series of recordings held at the British Library Sound archive.
10. Bickford, *The Dissonance of Democracy*, 102.
11. Niamh Stephenson and Papdopoulos, Dimitris, *Analysing Everyday Experience (Social Research and Political Change* (Basingstoke:

Palgrave Macmillan, 2006).

12. Arendt, "Action", in *The Human Condition*, 176.

13. Jean-Luc Nancy quoted by Cavarero, *For More Than One Voice*, 193.

14. Cavarero, *For More Than One Voice*, 180.

15. Barthes, *Listening*, 254-60.

16. Cavarero, *For More Than One Voice*, 196.

17. Florian Schneider, "Collaboration: The Dark site of the multitude". Accessed 7 April 2016: http://fls.kein.org/view/174.

18. Micropolitics Research Group blog, https://micropolitics.wordpress.com/

19. Marta Malo DeMolina: Common Notions, Part 2: Institutional Analysis, Participatory Action-Research, Militant Research, 2004. Accessed 7 April 2016: http://eipcp.net/transversal/0707/malo/en

20. Paulo Freire, *Pedagogy of the Oppressed*.

21. The aim and the scope of the project was to explore and create a communal space during the 100 days of Documenta 13.

22. Barthes, *Listening*, 246.

23. Ibid., 252.

24. Gilles Deleuze, "Three Group Related Problems" in *Desert Islands and Other Texts, 1953-1974* (Cambridge, Mass.: MIT Press, 2004), 193.

25. Franco Berardi 'Bifo', *The Soul at Work. From Alienation to Autonomy*, trans. by Francesca Cadel and Giuseppina Mecchia (LA: Semiotext(e) 2007), 220.

26. Cristina Morini, "The feminization of labour in cognitive capitalism", *Feminist Review* (2007) 87, 40–59. Accessed 7 April 2016: http://www.palgrave-journals.com/fr/journal/v87/n1/abs/9400367a.html.

27. Carrot Workers Collective, *Surviving Internships. A Counter Guide to Free Labour in the Arts*, Hato Press, 2011. Accessed 7 April 2016: https://carrotworkers.wordpress.com/counter-internship-guide.

Chapter 5: Institutional Frameworks

1. The Serpentine Gallery Map Marathon, 16-17 October 2010 (the fifth in the Serpentine Gallery's series of Marathons) which consisted in a weekend of over 50 presentations by artists, poets, writers, philosophers, scholars, musicians, architects, designers

and scientists.

2. e-Xplo along with Ayreen Anastas took part in the Sharjah Biennial 8, UAE where they produced "I LOVE to YOU: Workers' Voices in the UAE".

3. Jelinek, *This is Not Art*.

4. Ultra-red, *10 Preliminary Theses on Militant Sound Investigation* (New York City: Printed Matter. Inc., 2008)

5. AND AND AND. Accessed 7 April 2016: http://d13.documenta.de/#programs/the-kassel-programs/and-and-and/

6. Irit Rogoff, "We - Collectivities, Mutualities, Participations", 2004. Accessed March 2015: http://theater.kein.org/node/95

7. Ibid.

8. Nicolas Bourriaud, *Relational Aesthetics* (Dijon: Les presses du réel, 2002).

9. Stevphen Shukaitis, *Imaginal Machines. Autonomy & Self-Organization in the Revolutions of Everyday Life* (Minor Compositions, 2009), 31.

10. Ibid., 108

11. Gablik, *Connective Aesthetics*, 84.

Chapter 6: Ethics of Listening

1. Jonathan Lear, *Radical Hope. Ethics in the face of Cultural Devastation* (Harvard University Press, 2006), 103.

Chapter 7: Resonance and Recognition (or the politics of listening)

1. Axel Honneth, *Disrespect: The Normative Foundations of Critical Theory* (Cambridge: Polity Press, 2007).

2. Axel Honneth, *The Struggle for Recognition. The Moral Grammar of Social Conflicts*, trans. by Joel Anderson (Cambridge, Massachusetts, Polity Press, 1995), 128.

3. Lumley, *State of Emergency*.

4. Boris Groys, *The Politics of Equal Aesthetic Rights* (Rotterdam: BAVO editors, 2007), 108.

5. Lonzi notably resigned from her profession as an art critic in the late 60s to co-found Rivolta Femminile with artist Carla Accardi and writer Elvira Bannotti. After co-writing the first Manifesto, Rivolta Femminile established their own publishing house (*Scritti di Rivolta Femminile*) in order to circulate their ideas without risking misinterpretation.

6. "… il riconoscimento, da cui nasce il soggetto, intanto che espri-

me un altro soggetto in grado a sua volta di essere riconosciuto, è stata l'operazione che ha portato il mio processo al traguardo dell'autocoscienza". Carla Lonzi, *Taci anzi parla*. 7, translation by Lucia Farinati.

7. For example the text "Assenza della donna dai momenti celebrativi della cultura maschile" (The absence of the woman from the celebratory moments of male culture), Rivolta Femminile, Milan, March, 1971.

8. Her diary, *Taci anzi Parla* (Shut up, Speak rather) includes her poems, letters and dreams.

9. See the articles published on *Reflections on Process in Sound*, issue 2 winter 2013 (http://www.reflections-on-process-in-sound.net). For a preliminary discussion about the work of Carla Lonzi see also the project *Come una possibilità di incontro* (As a possibility of an encounter) by Lucia Farinati in collaboration with bip bop (Bologna 2013-14). https://bipbopweb.wordpress.com/episode-6/

10. Cavarero, *Relating Narrative*, p. x.

11. Bickford, *The Dissonance of Democracy*, 2

12. Kei Yamamoto, *Beyond the Dichotomy of Agonism and Deliberation: The Impasse of Contemporary Democratic Theory*, 2011. Accessed 7 April 2016: http://www.lang.nagoyau.ac.jp/bugai/kokugen/tagen/tagenbunka/vol11/13.pdf.

13. Bickford, *The Dissonance of Democracy*, 146.

14. Cavarero, *For More Than One Voice*, 206.

15. Nancy, *Listening*.

16. Cavarero, *For More Than One Voice*, 205.

17. Ibid., 201.

18. Ibid., 204.

Chapter 8: Occupy

1. Lucia Farinati, "Occupy London Stock Exchange: la protesta a Londra, 2011". Accessed 7 April 2016: http://www.doppiozero.com/materiali/cartoline-da/occupy-london-stock-exchange-la-protesta-londra

2. Amy Schrager Lang and Daniel Levitsky, *Dreaming in Public, Building the Occupy Movement* (Oxford:, New Internationalist Publications Ltd. , 2012), 300.

3. Ibid., 290.

4. David Graeber, *The Democracy Project: A History, a Crisis, a Move-*

ment (New York: Spiegel & Grau, 2013), 299.

5. Ibid., 300.

6. Ibid., 322.

7. http://16beavergroup.org/everything

8. Sarah Van Gelder, ed. by, *This Changes Everything: Occupy Wall St and the 99% Movement* (San Francisco: Berrett-Koehler Publishers Inc, 2011), 8.

9. Arendt, *The Human Condition*, 198.

Bibliography

Ahmed, Sara. *Strange Encounters: Embodied Others in Post-Coloniality* (New York: Routledge, 2000).

AND AND AND: http://d13.documenta.de/#programs/the-kassel-programs/and-and-and/

Arendt, Hannah. *The Human Condition* (Chicago: University of Chicago Press, 1958).

Barthes, Roland. "Listening", in *The Responsibility of Forms: Critical Essays on Music, Art, and Representation*, trans. Richard Howard (New York: Hill and Wang, 1985) 245-60.

Berardi, Franco 'Bifo'. *The Soul at Work. From Alienation to Autonomy*, trans. by Francesca Cadel and Giuseppina Mecchia (LA: Semiotext(e), 2007).

Bickford, Susan. *The Dissonance of Democracy: Listening, Conflict, and Citizenship* (Ithaca, N.Y.: Cornell University Press, 1996).

Biserna, Elena, Correddu, Rita and Farinati, Lucia. "From *Autoritratto* to *Come una possibilita' di incontro*", in *Reflections on Process in Sound* (2) edited by Iris Garrelfs, Summer 2014: http://irisgarrelfs.com/wp-content/uploads/2012/09/Reflections-on-Process2.pdf.

Born, Georgina, ed. *Music, Sound and Space. Transformation of Public and Private Experience* (Cambridge University Press, 2013).

Bourriaud, Nicolas. *Relational Aesthetics,* trans. by Simone Pleasance & Fronza Woods with the participation of Mathieu Copeland (Les presses du réel, 2002).

Brown, Wendy. "American Nightmare: Neoliberalism, Neconservatism and De-Democratization", *Political Theory*, Volume 34, DATE? Number 6, 690-714.

Carlyle, Angus and Lane, Cathy. *On Listening* (Uniformbooks, 2013).

Cavarero, Adriana. *For More Than One Voice: Toward a Philosophy of vocal expression*, translated and with an introduction Paul A. Kottman (Stanford: Stanford University Press, 2005).

Cavarero, Adriana. *Relating Narrative: Storytelling and Selfhood*, translated and with an introduction by Paul A. Kottman (Warwick Studies in European Philosophy 2000).

Couldry, Nick. *Why Voice Matters. Culture and Politics after Neo Liberalism* (London: Sage, 2010).

Cox, Christoph and Warner, Daniel, eds. *Audio Culture. Readings in Modern Music* (London: Continuum, 2008).

Deleuze, Gilles. "Three Group Related Problems" in *Desert Islands and Other Texts - 1953-1974* (Cambridge, Mass.: MIT Press, 2004) 193-203 http://orkney-solstice.wikispaces.com/file/view/Desert+Islands.pdf.

DeMolina, Marta Malo. "Common Notions, Part 2: Institutional Analysis, Participatory Action-Research, Militant Research", 2004: http://eipcp.net/transversal/0707/malo/en.

Dolar, Mladen. *A Voice and Nothing More* (Cambridge, Mass.: The MIT Press, 2006).

Farinati, Lucia and Firth, Claudia. "Reversals and Recognition: An Interview about Process", in Reflections on Process in Sound (2) edited by Iris Garrelfs, Summer 2014: http://irisgarrelfs.com/

wp-content/uploads/2012/09/Reflections-on-Process2.pdf.

Farinati, Lucia. "Occupy London Stock Exchange: la protesta a Londra", 2011: http://www.doppiozero.com/materiali/cartoline-da/occupy-london-stock-exchange-la-protesta-londra.

Freeman, Jo. *The Tyranny of Structurelessness*. 1970: www.jofreeman.com/joreen/tyranny.htm.

Freire, Paulo. *Pedagogy of the Oppressed* (New York: Continuum, 1970).

Gablik, Suzi. "Connective Aesthetics: Art after Individualism", in *Mapping the Terrain – New Genre Public Art*, ed. by Suzanne Lacy (Seattle, Washington: Bay Press, 1995), 74-87.

Graeber, David. *The Democracy Project: A History, a Crisis, a Movement* (New York: Spiegel & Grau, 2013).

Groys, Boris. *The Politics of Equal Aesthetic Rights* (Rotterdam: BAVO 2007).

Hanisch, Carol. "The Personal is Political", 1970: www.carol-hanisch.org/CHwritings/PIP.html.

Holloway, John. *Crack Capitalism* (London: Pluto Press, 2010).

Honneth, Axel. *Disrespect: The Normative Foundations of Critical Theory* (Cambridge: Polity Press, 2007).

Honneth, Axel. *The Struggle for Recognition. The Moral Grammar of Social Conflicts*, trans. by Joel Anderson (Cambridge, Massachusetts, Polity Press, 1995).

http://www.womensliberation.org/

Ihde, Don. *Listening and Voice, Phenomenologies of Sound* (NY: State University of New York Press, Albany, 2007).

Jelinek, Alana. *This is Not Art. Activism and Other 'Not-Art'* (Lon-

don, New York, I.B. Tauris, 2013).

Kahn, Douglas. *Noise, Water, Meat. A History of Sound in the Arts* (Cambridge, Mass.: The MIT Press, 2001).

Kanngieser, Anja. "Toward a careful listening", in *Nanopolitics Handbook* ed. by Paolo Plotegher, Manuela Zechner, Rübner Hansen (Wivenhoe, New York, Port Watson: Minor Composition, 2013) 235.

Kim-Cohen, Seth. *In the Blink of an Ear. Toward a non-cochlear sonic art* (New York: Continuum, 2009).

LaBelle, Brandon. *Acoustic Territories, Sound Culture and Everyday Life* (New York: Continuum, 2010).

LaBelle, Brandon. *Background Noise. Perspectives on Sound Art* (New York: Continuum, 2006).

Lacy, Suzanne. *Mapping the Terrain: New Genre Public Art* (Seattle, Washington: Bay Press, 1995).

Lear, Jonathan. *Radical Hope. Ethics in the face of Cultural Devastation* (Harvard University Press, 2006).

Lonzi, Carla. *Taci anzi parla. Diario di una femminista, 1978* (Milano: et al. Edizioni, 2010).

Lumley, Robert. *State of Emergency. Culture of Revolt in Italy from 1968 to 1978* (London, New York: Verso, 1990).

Micropolitics Research Group, blog, https://micropolitics.wordpress.com/

Morini, Cristina. "The feminization of labour in cognitive capitalism", *Feminist Review*, 2007, 87, 40–59: http://www.palgrave-journals.com/fr/journal/v87/n1/abs/9400367a.html.

Nancy, Jean-Luc. *Listening*, trans. by Charlotte Mandell (New York: Fordham University Press, 2007).

Oliveros, Pauline. "Deep Listening: Bridge to Collaboration", Keynote address, ArtSci98: Seeding Collaboration, Copper Union, New York City, April 4-5, 1998: www.asci.org.

Oliveros, Pauline. "Quantum Listening: From Practice to Theory (To Practice Practice)", Music Works, Issue #76 (Spring 2000), 73.

Rancière, Jaques. *The Politics of Aesthetics. The Distribution of the Sensible,* trans. with and Introduction by Gabriel Rockhill (London, New York, Continuum, 2004).

Rivolta Femminile. "Assenza della donna dai momenti celebrativi della cultura maschile", Milan, March, 1971, in Carla Lonzi, *Sputiamo su Hegel e altri scritti* (Milano, et al. Edizioni, 2010).

Roden, Steve. *Active Listening,* soundwalk catalog, 2005: http://www.inbetweennoise.com/texts/active-listening/

Rogoff, Irit. "We - Collectivities, Mutualities, Participations", 2004: http://theater.kein.org/node/95.

Rolnik, Suely. "The Body's Contagious Memory. Lygia Clark's Return to the Museum", trans. by Rodrigo Nunes, 2007: http://eipcp.net/transversal/0507/rolnik/en.

Sarachild, Kathie. *Consciousness-Raising: A Radical Weapon. Document from the Women's Liberation Movement*, Duke University, 1978: httPat://internal.rapereliefshelter.bc.ca/issues/Conciousness-Raising_A_Radical_Weapon.html.

Schneider, Florian. "Collaboration: The Dark site of the multitude", 2006: http://fls.kein.org/view/174.

Schrager Lang, Amy and Levitsky, Daniel. *Dreaming in Public, Building the Occupy Movement* (Oxford, UK: New Internationalist Publications Ltd., 2012).

Shukaitis, Stevphen. *Imaginal Machines. Autonomy & Self-Organization in the Revolutions of Everyday Life* (Minor Composition, 2009).

Spender, Dale. *Man Made Language* (London; Boston: Routledge & Kegan Paul, 1980).

Spivak, Gayatri. 'Translator's Preface and Afterword to Mahasweta Devi, "Imaginary Maps"', in *The Spivak Reader*, ed. Donna Landry and Gerald MacLean (New York: Routledge, 1996).

Stephenson, Niamh and Papadopoulos, Dimitris, *Analysing Everyday Experience: Social Research and Political Change* (Basingstoke: Palgrave Macmillan, 2006).

The Milan Women's Bookstore Collective. *Sexual Difference. A theory of Social-Symbolic Practice* (Bloomington and Indianapolis Indiana University Press, 1990).

Ultra-red. *10 Preliminary Theses on Militant Sound Investigation* (New York: Printed Matter, 2008).

Van Gelder, Sarah, ed. *This Changes Everything: Occupy Wall St and the 99% Movement* (San Francisco: Berrett-Koehler Publishers Inc, x, 2011).

Virno, Paolo. "Virtuosity and Revolution: The Political Theory of Exodus", trans. by Ed Emery, 1996: http://www.generation-online.org/c/fcmultitude2.html

Voegelin, Salomé. *Listening to Noise and Silence: Towards A Philosophy Of Sound Art* (New York: Continuum, 2010).

Weiss, Allen S. *Breathless. Sound Recording, Disembodiment and the Transformation of Lyrical Nostalgia* (Middletown: Wesleyan University Press, 2002).

West, Rebecca, Marcus, Jane. The Young Rebecca: Writings of Rebecca West : 1911-17 (Bloomington: Indiana University, 1989).

Yamamoto, Kei. *Beyond the Dichotomy of Agonism and Deliberation: The Impasse of Contemporary Democratic Theory*, 2011: http://www.lang.nagoyau.ac.jp/bugai/kokugen/tagen/tagenbunka/vol11/13.pdf

Biographies

Lucia Farinati is a researcher, curator and activist. In 2007 she established Sound Threshold, an interdisciplinary curatorial project that explores the relationships between site, sound and text. She has worked with the Precarious Workers Brigade and the Micropolitics Research Group and has collaborated with many sonic art projects and radio initiatives including Helicotrema, bip bop, Errant Bodies, Audio Arts, Resonance 104.4 FM, Institution of Rot, e-Xplo, Radio Papesse and Radio Arte Mobile. Her research focuses on dialogic aesthetics, especially on the work of artist William Furlong and the feminist writing of Carla Lonzi which she has activated through collective readings and radio broadcasts. She is currently working on an extensive research project on *Audio Arts* in collaboration with Tate Archive as part of her PhD at Kingston University - FADA, London.

Claudia Firth is currently a PhD researcher at Birkbeck College, University of London in Cultural and Critical Studies. Her PhD is a non-linear history of three moments of post-economic crises (30's, 70's and the present) inspired by the historical novel *The Aesthetics of Resistance*. She has a background as a visual artist and facilitates workshops in both arts and activist arenas. She has worked with activist groups such as the Precarious Workers Brigade and the Radical Housing Network. Her current research interests are organization and collective knowledge production, tools and machines, and the intersection between aesthetics, affect and politics. She has written on a variety of subjects including the sharing economy, art and protest, disability and technology, and governmentality. Her writings include articles for Nyx, the journal for the Centre for Cultural Studies at Goldsmiths, University of London, Dandelion, the journal at Birkbeck College and DIS online magazine.

Ayreen Anastas and Rene Gabri are artists currently living between a megalopolis and a small mountain village. Taking life as a form of writing, engaging, playing, experimenting, often collectively, with friends (e.g., 16 Beaver Group, e-Xplo, Centre for Parrhesia, Society for the Diffusion of Useful Knowledge, Un Groupe Comme les Autres...), constructing and inhabiting planes

of consistency with fellow commoners (e.g., AND...AND...AND, Commoning Times...) and struggling to engage and confront the dominant forms of modelization of subjectivity - the two are most interested in processes which nurture a common and concurrently multiply the paths of singularization and autonomy.

Founded in 1994 by AIDS activists, the collective Ultra-red has expanded to include artists, researchers and organisers from different social movements. They operate both as an artistic and activist practice and are often related to sound activism. Ultra-red explores how sound-based research (termed Militant Sound Investigations) can support long-term political organizing focused on, among many other concerns, housing, health, education and (im)migration. Robert Sember joined Ultra-red in 2005 for SILENT | LISTEN, a project focused on the AIDS crisis in North America. He now facilitates the collective's Vogue'ology project, a long-term collaboration with the predominantly LGBTQ African American and Latino/a House and Ballroom Scene in New York City. Janna Graham first collaborated on the Ultra-red project ARTICLES OF INCORPORATION at Art Metropole, Toronto in 2005. Graham has also initiated a number of radical pedagogy projects combining popular education, action research and the arts. That work continues with Graham's involvement in Ultra-red projects such as DUB CURRICULUM based in Torbay and WE COME FROM YOUR FUTURE, presented at Tate Britain in 2008.

Precarious Workers Brigade (PWB) are a UK-based group of precarious workers in culture & education. PWB call out in solidarity with all those struggling to make a living in this climate of instability and enforced austerity. PWB's praxis springs from a shared commitment to developing research and actions that are practical, relevant and easily shared and applied. Their political project involves developing tactics, strategies, formats, practices, dispositions, knowledge and tools for making this happen. PWB has recently published *Training for Exploitation? Politicising Employability and Reclaiming Education*, a resource book for educators teaching employability, 'professional practice' and work-based learning. The publication provides a pedagogical framework that assists students and others in deconstructing dominant narratives around work, employability and careers, and explores alternative

ways of engaging with work and the economy. Published by the Journal of Aesthetics & Protest, 2017, with a foreword by Silvia Federici.

Pat Caplan is Emeritus Professor of Anthropology at Goldsmiths. She has carried out extensive research in Tanzania and India, on which she has published books and articles, and has also been involved in a number of movements for social justice including feminism. Her current research project is on food poverty and food aid in the UK.

Adriana Cavarero is an Italian philosopher and feminist thinker, her work focuses on philosophy, politics and literature. She has taught at the University of Verona. Her books in English include *In Spite of Plato* (Polity 1995); *Relating Narratives* (Routledge 2000); *Stately Bodies* (Michigan U.P. 2002); *For more Than One Voice* (Stanford U.P 2005); *Horrorism* (Columbia U.P. 2009); *Inclinations* (Stanford U.P 2016).

Nick Couldry is a sociologist of media and culture. He is Professor of Media, Communications and Social Theory at the London School of Economics and Political Science. He is the author or editor of 11 books, including *Media Society World: Social Theory and Digital Media Practice* (Polity 2012) and *Why Voice Matters* (Sage 2010). He is currently working on a book with Andreas Hepp on *The Mediated Construction of Reality* (Polity).

anna sherbany is a London based visual artist and lecturer. She lectures in Visual Language and the Photographic Image and has taught at Kingston University, Norwich School of Art and in academies in Europe and the Middle East. Her artwork has been exhibited in museums and galleries internationally including EVA International Biennale, Ireland, ICA London, Museum of London and San Salvador National Museum, El Salvador. In her work anna probes and explores themes of memory, migration and (dis) location, through direct interaction and engagement with people, transmitting and preserving their authentic voices, via her artwork, for the present and the future.

Dates and places of the recorded conversations

The conversation with Ayreen Anastas and Rene Gabri was recorded on the occasion of their residency in London at Delfina Foundation/The Showroom during which they also organized with friends the Common(s) Course hosted by various collectives/spaces in London, March 2014.

The conversation with Janna Graham and Robert Sember was recorded on the 17th April 2013 on the occasion of their project RE:ASSEMBLY at the Serpentine Gallery, London.

The recorded conversation with the collective PWB was made in North London, in April 2014. It included 8 members of PWB who feature in the book under the fictitious names of Amy, Alex, Chloe, Lola, Martha, Maria, Mila and Tanya.

Pat Caplan was recorded at her home in North London in May 2013.

Adriana Cavarero's parts included in this book are excerpts from a recorded interview conducted by Lucia Farinati (in collaboration with the artist Mikhail Karikis) in Verona, Italy on the 10th March 2011. The interview has been transcribed from the Italian and translated into English by Lucia Farinati for this publication.

Nick Couldry was recorded at Goldsmiths College, London on the 15th May 2013.

The conversation with Anna Sherbany was conducted and recorded by Claudia Firth in North London in May 2013.

All the recordings were made by Lucia Farinati and Claudia Firth.

The Force of Listening
Lucia Farinati & Claudia Firth

ISBN: 978-0-9978744-0-2

Errant Bodies Press: DOORMATS[6]
Berlin, 2017
www.errantbodies.org

Series editors: Riccardo Benassi and Brandon LaBelle
Printed: druckhaus köthen

Focusing on contemporary issues, events, and discourses, DOORMATS
is a series of publications aimed at contributing to the now, talking about
issues that are present and that demand presence.

DOORMATS[1] - Franco Berardi Bifo
Skizo-Mails

DOORMATS[2] - Brandon LaBelle
Diary of an Imaginary Egyptian

DOORMATS[3] - Valentina Montero
By Reason or By Force

DOORMATS[4] - Fred Dewey
The School of Public Life

DOORMATS[5] - Riccardo Benassi
Techno Casa

DOORMATS[6] - Lucia Farinati & Claudia Firth
The Force of Listening

DOORMATS[7] - Israel Martínez
Resounding Roar